IMAGES
of America

WALKER COUNTY
COAL MINES

On the Cover: This miner is loading dynamite into a coal car at the Railway Fuel Mine in Parrish. Dynamite was and is still essential to mining. (Courtesy of Mine Safety and Health Administration.)

Iris Singleton McAvoy

Copyright © 2016 by Iris Singleton McAvoy
ISBN 978-1-4671-1496-7

Published by Arcadia Publishing
Charleston, South Carolina

Printed in the United States of America

Library of Congress Control Number: 2015941755

For all general information, please contact Arcadia Publishing:
Telephone 843-853-2070
Fax 843-853-0044
E-mail sales@arcadiapublishing.com
For customer service and orders:
Toll-Free 1-888-313-2665

Visit us on the Internet at www.arcadiapublishing.com

This book is dedicated to my father, James Singleton, my grandfather J.D. Daniel, and all of the hardworking miners whose sweat and blood built Walker County. These miners spent their days underground so that their families could live comfortably on the land above. And in memory of my grandmother Lucille Singleton, with whom I spent so many days at the Alabama Mining Museum. Nathan McAvoy, may this remind you of the stock of which you are made. May you always remember and strive to encompass the hardworking ethic and characteristics of the miners.

Contents

Acknowledgments		6
Introduction		7
1.	The Mines	9
2.	Mining Life	81
3.	Walker County Today	123

Acknowledgments

There is a saying: "It takes a village to raise a child." Well, it took a county of unselfish people to make this book. I wish that I had enough room to recount all of the wonderful stories I heard and mention all of the interesting people I met during the process of producing this book. Coal mining is more than a history or a job here. It is a way of life, a community, and a family that I am sure is uniquely Walker County.

A big thanks goes to Horace and Susan Defore for sharing their unmatched, lifetime collection of photographs and knowledge of mining history. An avid coal historian, Horace Defore's work with McWane Coal and his childhood in Sipsey inspired him to begin his collection. He devoted a lifetime to collecting photographs from local mines. His collection can still be viewed at Defore's Hardware, which he ran for 23 years. Sadly, Horace passed away on August 24, 2015, before this book was published. This book could not have been possible without him.

I would like to thank Charles Whitson, mine inspector for the state of Alabama, and local historian Pat Morrison for taking the time to speak and share collections with me. I cannot thank enough the Drummond Company and Krystal Drummond for readily contributing to this book and sharing both the company and family history. Without you, this book would not have been possible. I appreciate the kindness of DeAnna Sanders, Evelyn Garrett, and all of the sweet people at the Oakman Senior Center, as well as Gene McDaniel and the SEGCO retirees.

I would like to thank for their time the following individuals and institutions: Elizabeth Blanton and Jennifer Eads at the Carl Elliot Library, Deborah Lentz, Howard Schultz, Kenneth Ely, Nancy Stewart at the Carbon Hill City Library, Rick Watson, Paul Kennedy, the Alabama Mining Museum, Mike Farris at collectingalabama.com, the UMWA District 20, Floyd and Lloyd Burton, Professor Gupta, Margaret Parker, Rhonda Guthrie, Dean Al Moore at Bevill State, Ron McCarty with the Bevill State Mining Program, Melody Bragg and William Francart and the wonderful staff at the Mine Safety and Health Administration, Laura Gottesman at the Library of Congress, Maurice Lovelady with the Walker County Genealogical Society, and Frank Stillwell. Thanks to Ralph Hawkins for his wonderful collection of historic photos. Thanks also to Cynthia Patton, Sara Clark, and other prayer warriors for prayers throughout this process.

I would like to thank my family for bearing with me during this process. This includes my mom, dad, granny, sister, aunt, and son. Tim Hollis, you have my eternal thanks. Without you, this book might have never been written. Sarah Gottlieb, thank you for your help and guidance. You are unmatched. I would also like to thank all of the hardworking miners who built this special county and its rich history.

INTRODUCTION

In Walker County, coal mining is a family tradition that began before the Civil War. Generations of families have mined the Appalachian foothills. For those born here, chances are good that they are related to, or are, a coal miner. Anyone who knows a miner realizes that there is a great sense of pride in the coal heritage. If Birmingham is the "Magic City" because of the steel industry, then Walker County's coal dust fueled that magic. It was by the sweat and brow of coal miners that this county was built.

It is said that coal was discovered in Alabama in Walker County. According to Oakman city clerk Deanna Sanders, "Two boys were camping after hunting along Lost Creek. The pair built a fire that night and placed rocks around it. They awoke in the middle of the night to see that the rocks glowed. They were terrified."

The discovery changed Walker County forever. The earliest settlers began to mine coal throughout the county. James Cain and Jesse Van House are said to have opened the first drift mine in the state. At the time, the Warrior River was the only way to ship coal. Many people, including James Cain, Judge Howette, Jacob Phillips, the Sanders, the Gravlees, James Davis, Reuben Morgan, and John Sullivan, began to mine coal. The settlers would often build rafts to transport the coal, then disassemble them, sell the wood, and walk home. At this time, there was no mining equipment. Miners used whatever tools they had at hand to pick coal out of the ground. Soon, mining became a way of life and a way to supplement farming income. When the Civil War began, Walker County had few slaves, but it joined the war. Eventually, the Union soldiers began to stop all commercial coal.

After the war, it was not until the railroad expanded that mining was revived. Soon, coal companies, along with local politicians such as L.B. Musgrove, lobbied the railroad to come through their town. The railroad began to be built in Walker County, bringing change to the once quiet county. In 1884, the first coal in the county was shipped in Corona. Carbon Hill, Kansas, Dora, Jasper, Holly Grove, and Townley were all put on the map by the railroad. Although local pioneers still mined in wagon drift mines around the county to supplement their income, big coal companies began to settle in the county. The United Mine Workers of America (UMWA) tried to organize during this time, but its efforts were futile. Several miners and union organizers were arrested for trying to incite a strike.

After the turn of the 20th century, coal began to regain momentum. The South began to rebuild, the North began to industrialize, steam engines needed coal, and cities needed power. A steam plant was built along the Warrior River. Charcoal became a thing of the past, and coke was the way of the future. Many of the coal companies that had gone belly-up began to reorganize under new names. New mining camps began to sprout up all over Walker County.

The only problem was that many farmers were not anxious to leave their way of life. These farmers had used coal to supplement their income. Mining companies soon sent labor recruiters to places such as Ellis Island to entice workers to live in mining camps. Many Walker County farmers sold their mineral rights without realizing the monetary value. Still, coal became the biggest industry in the county. Walker County was called by many the greatest coal county in the South. The 20th century saw a revolution in the coal industry. While mules were still used by mines, new machinery did away with picks. Companies began to make their own power from the coal, and machines could do the work of 20 miners. Mining companies began welfare programs to entice immigrants to come to Walker County to work.

"These were not actually welfare programs," explained Charles Whitson, a local mine historian and state inspector. "The people worked for these programs." Indeed, they did. At the Corona Coal Company, workers paid $1.25 a month for use of the college and school. At DeBardeleben's Sipsey camp, workers paid for access to the dairy farm and for the school. Companies matched the money that workers paid in order to fund these programs.

The UMWA began to try to organize in Walker County, which had few unionized mines. The few times that miners had tried to unionize and strike, such as in 1887 because of reduced wages, they were not recognized and went back to work. In 1890, miners struck at the Carbon Hill Coal & Coke Company when new workers were brought in. In 1903, a labor organizer, Joe Hollier, was shot near Horse Creek after trying to unionize the Empire Coal Company. In 1908, a strike began at the Tennessee Coal & Iron Company in Birmingham, and spread to Walker County. Blacks and whites both struck, trying to raise hourly rates. Coal companies used the racial equality underground to incite ire against the UMWA. An article supposedly written about a UMWA strike in Jasper described black and white people walking out together. It was during this time that black miners were evicted from company housing around Horse Creek. These miners left the camp to live in tents, vowing to never live in company housing again. They settled in Union Camp. Eventually, the strike was called off.

Soon, World War I began, and coal was needed for the war effort. The industry began to boom. The UMWA, noticing the growth, tried to organize again in 1920. Companies began to form their own "yellow dog" unions. John L. Lewis called for a strike. On September 16, tensions at Corona Coal Company had risen to a boil. The company deputies and foremen had harassed workers to a breaking point. General manager Leon Adler learned that a group of 50 protesters were headed to the mines. He rallied a group of 25 people, including county deputies, to try to stop the protestors from confronting the "scabs," or picket-line crossers. En route to the mines, Adler, Deputy Sheriff Earl Edgil, and a Deputy Brown were shot. When Gov. Thomas Kilby heard of the murder, he dispatched 500 state troops to the area. By December, Willie Baird famously defended his father-in-law after he was shot by Alabama troops. Governor Kilby refused to recognize the UMWA, and the strike came to an end. The union waited in the shadows.

Tragedy then struck the coal industry. The Great Depression hit, and many mining companies went belly-up. Those that survived became huge juggernauts in the industry. During the Depression, a new president brought change. A bill was passed that recognized unions for the first time on a federal level. The UMWA was recognized, and prepared to unionize Walker County mines. Mining-camp deputies were installed to help disrupt union efforts. As a result, Walker County was once again on the front lines. Many miners began to sneak over fences to escape non-unionized mining communities to work in union mines. Some mines began to use the unions and racial equality as an excuse to close.

When World War II began, coal was in high demand again. Coke ovens now operated all around the county, and most of the mines became motorized. Coal prices began to soar. The workers now had bargaining power, but the happy days were short-lived. Cities began to switch to natural gas, and railroads slowly transitioned to diesel engines. Highways and interstates were replacing rail lines as the main mode of transportation. It seemed that the great coal days were on the decline. However, Walker County possessed coal that was integral to steel production. While many coal companies and houses began to disappear, all was not lost. Strip pit operators began to sprout up throughout the county. ABC Coke, operated by the Drummond Company, began to thrive. This led to years of coal jobs in Walker County while the rest of the mining industry was shrinking. Walker County became the leading coal producer in the state.

Today, Walker County possesses only the ghosts of mining past. While there are still strip-mining operations, most of the underground mines have been sealed. The mining camps are gone, but if one knows where to look, mine ruins point to a day when mining was king. Evidence of the county's mining history still exists. Every city has streets that honor past mining companies. The history of Walker County is the history of coal. Miners still gather for reunions and talk about the "glory days." It is a history that will never completely disappear, because mining is ingrained in the heart of Walker County. Indeed, it is the pride of Walker County.

One
THE MINES

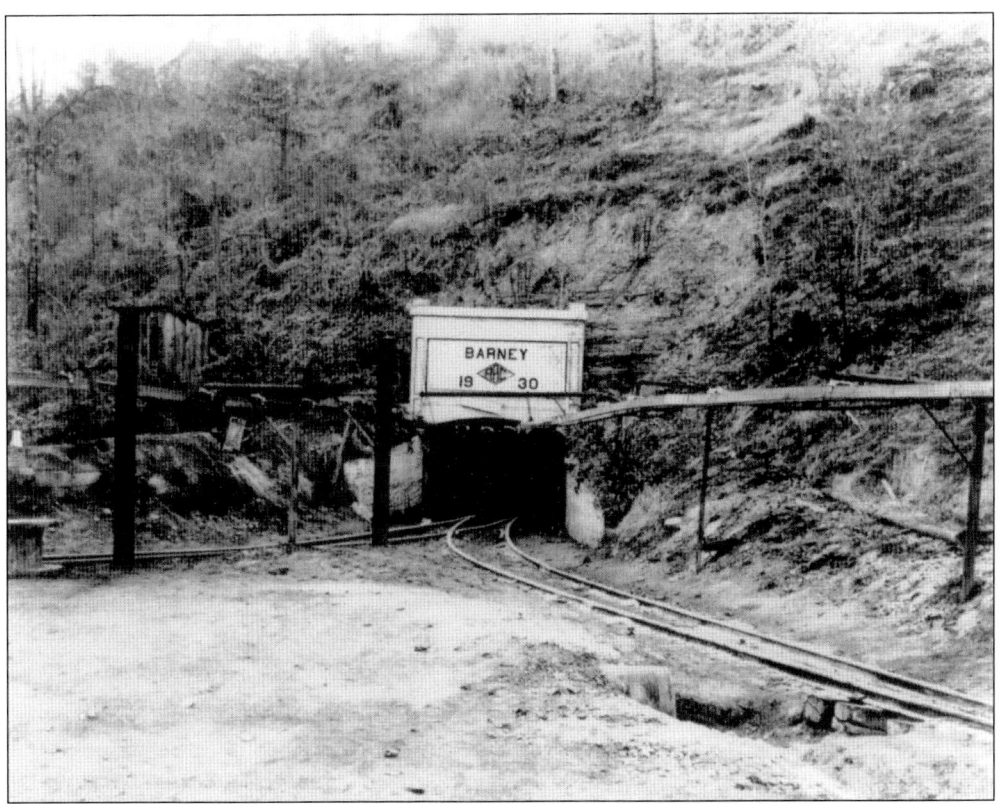

Barney Mine was one of the first mines to open in the county. Long before coal companies came into play, families began mining coal at Barney. Later, the mine was run by Barney Coal Company and was eventually bought out by Alabama By-Products. Barney Mine is unique in that most of the coal was transported directly on the Warrior River. In 1911, the mine caused quite a stir when oil was discovered inside. (Courtesy of Mine Safety and Health Administration.)

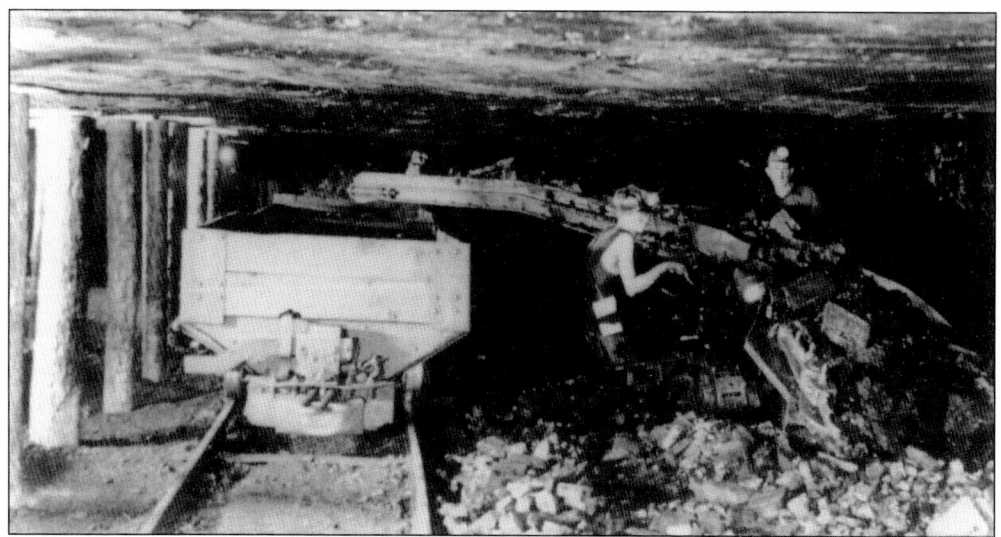

This 1936 photograph was taken at the Hull Mine, owned by the DeBardeleben Coal Corporation. It shows the 80-foot-long face and the loading machine. Note the young boy in the photograph. Boys were hired as trappers, whose job was to open and shut doors to prevent airflow in the mines, or as pushers, who pushed the coal in mining carts. Here, it seems the boy is assisting the miner in gathering coal. (Courtesy of Mine Safety and Health Administration.)

This is a more recent photograph of the Empire No. 3 mine, taken in 1964. The worker is using a mining machine to dig coal out of the coal seam. The height of the mine depends on the coal seam. (Courtesy of Horace Defore.)

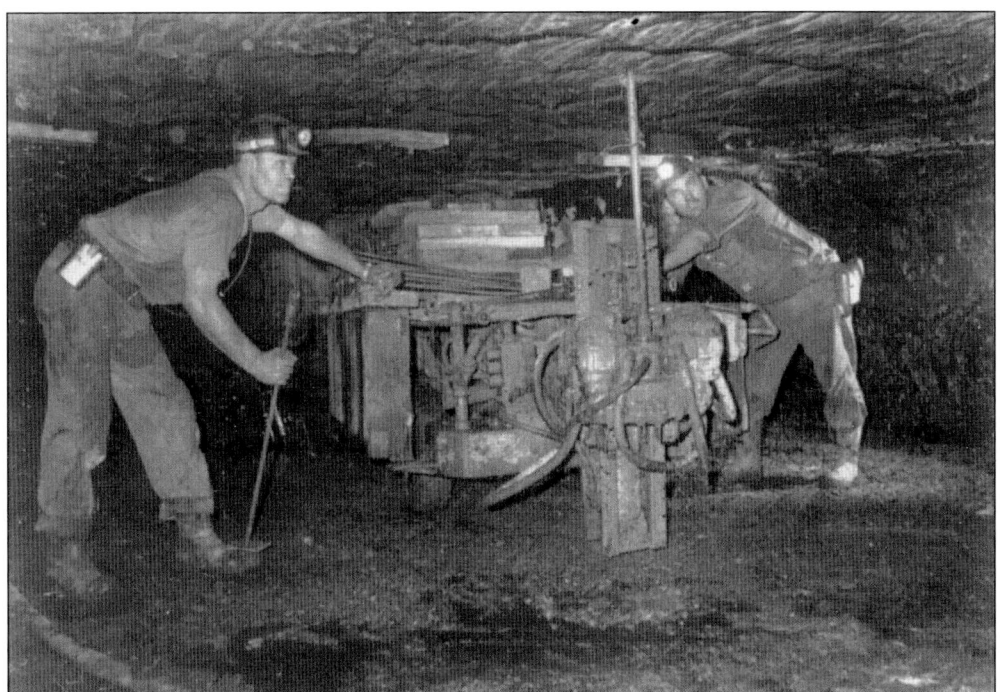

These miners are using a pinning machine to stabilize the roof at the Southern Electric Generating Company (SEGCO) mine. The machine bores a hole into the roof, making it possible to insert a bolt. The SEGCO mine was a part of the Mary Lee coal seam. (Courtesy of the Alabama Mining Museum.)

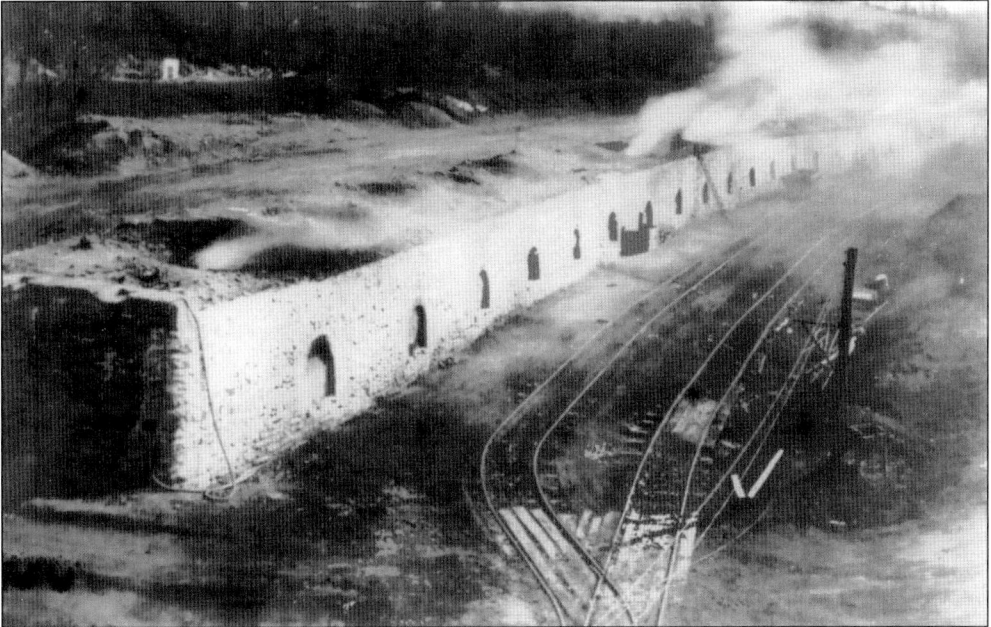

Brick beehive coke ovens were used to cook coal to make coke. The ovens were made of high-temperature bricks. These were once a common sight in Walker County. Jasper boasted over 400 ovens at one time. (Courtesy of Mine Safety and Health Administration.)

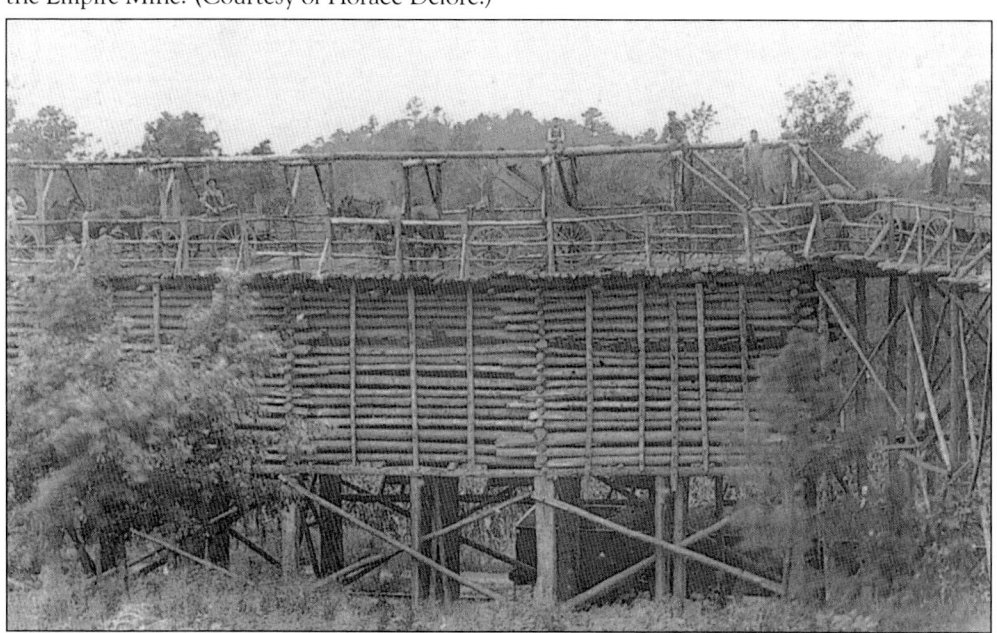

Surface mining increased in the 1960s, because this process became easier and more profitable than underground mining when the price of coal began to drop. Shown here is the high wall at the Empire Mine. (Courtesy of Horace Defore.)

A close look at this photograph reveals men and a mule on the tipple. The men are Louis Walton, Bill Anderson, Claud Sartain, Bevin Sartain, and Tom Gant. Gant later became the principal of Dora High School. (Courtesy of Pat Morrison.)

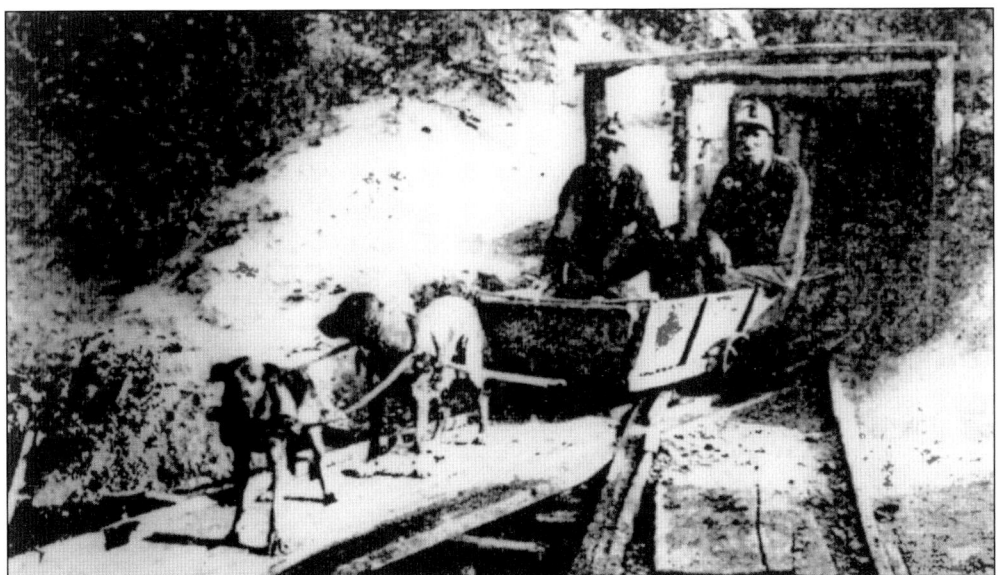
Most people know that mules were used in the early days of mining. In circumstances of low coal, however, mules were not always an option. Instead, dogs were used to haul coal out of the mines. (Courtesy of Mine Safety and Health Administration.)

F.A. Gamble (left) and L.B. Musgrove (right) were key figures in the history and development of coal in Walker County. The pair helped to form the Jasper Land Trust Company and, later, mines throughout the county, such as Gamble Mines in Jasper and Corona Coal Company. (Courtesy of Pat Morrison.)

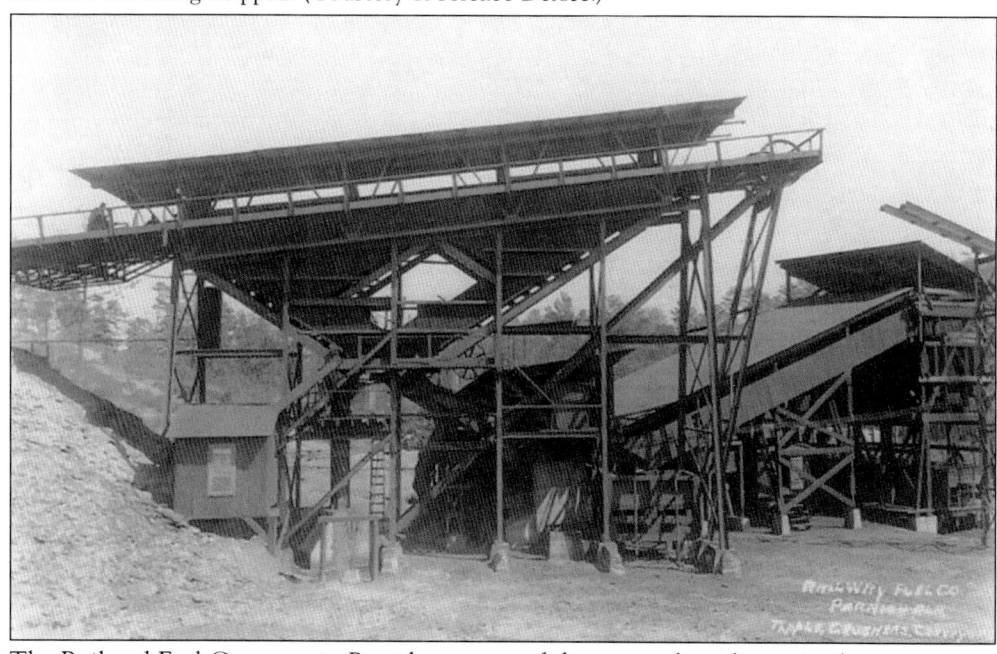

This 1967 aerial photograph of the Empire Mines shows the vast height of the high wall where the coal was being stripped. (Courtesy of Horace Defore.)

The Railroad Fuel Company in Parrish was one of the top coal producers in the state at one time. The mine brought the railroad into the town. As a result, Parrish experienced a population explosion. Coal cars dropped the coal onto the tipple, then the coal was crushed and hauled by the belt line to be sorted. (Courtesy of Horace Defore.)

This photograph was taken at a mine in Dora. Mr. Andrews, Susan Defore's grandfather, is seen here, second from left. Note the tipple in the background, built primarily of timbers. (Courtesy of Susan Defore.)

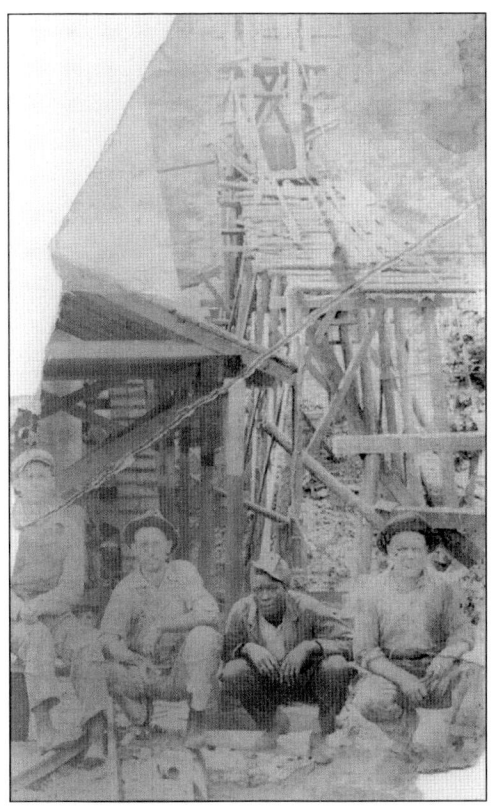

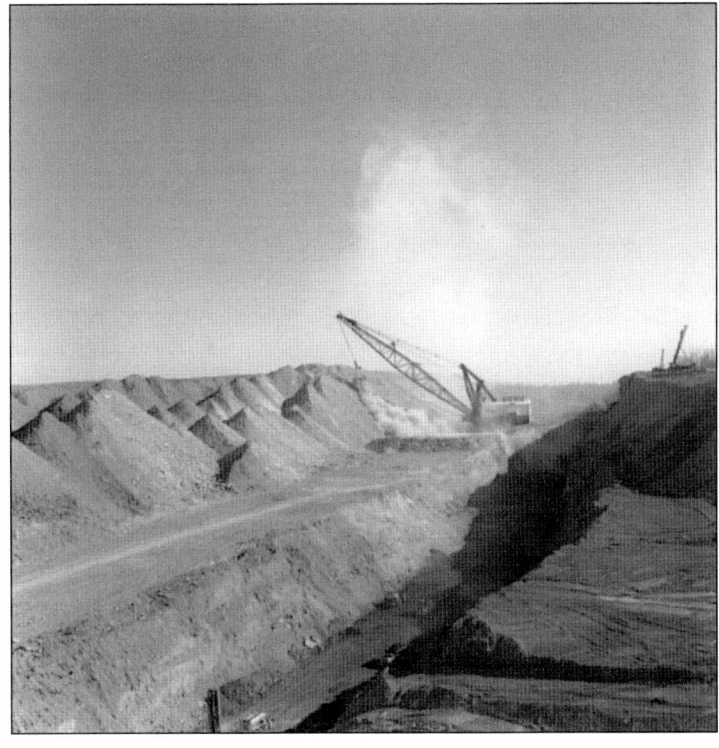

Shown here is Drummond Company's famous Ole Tobe dragline. The Cedrum Mine is located at Townley. The dragline is still there today, although the location closed many years ago. (Courtesy of the Drummond Company.)

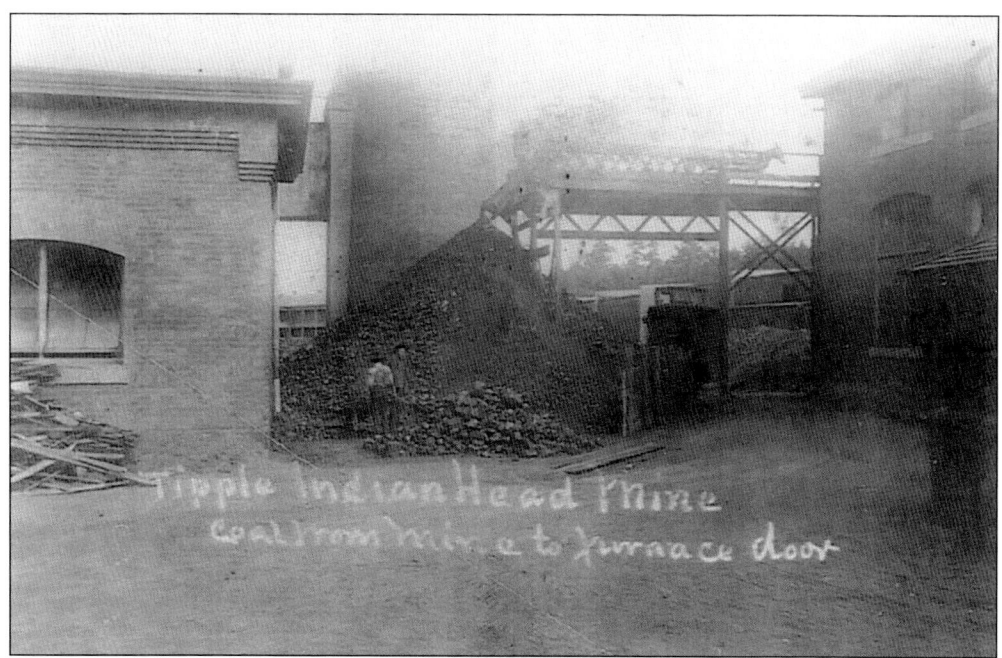

Few people know that the Indian Head Cotton Mill in Cordova had its very own coal mine to help power the mill. The coal from the mine was carried by a conveyor belt directly to the mill's furnace door. Loading the furnace was a hot and dangerous job. (Courtesy of Pat Morrison.)

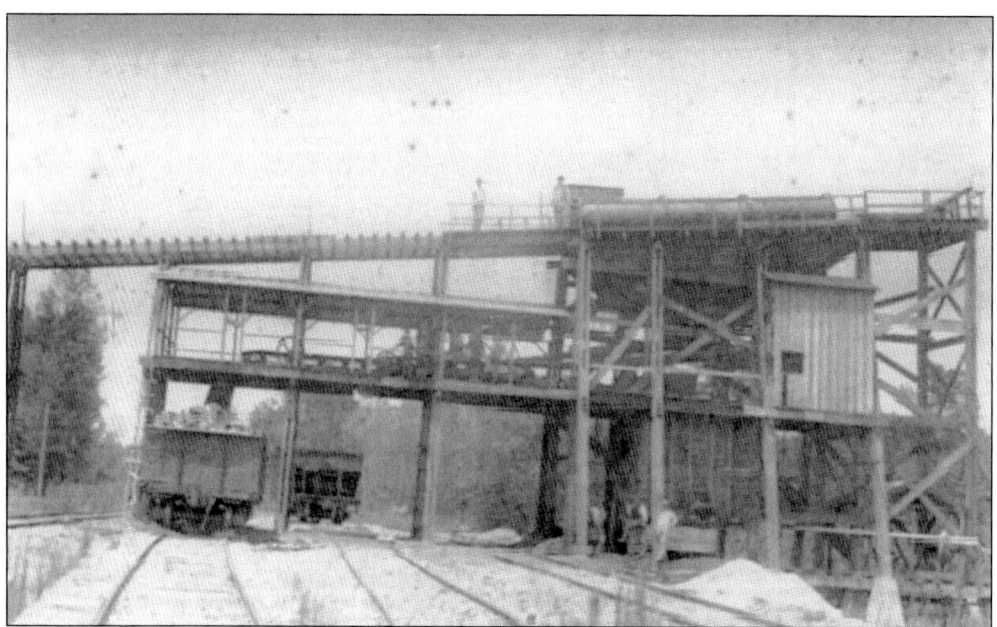

In the early days of mining, coal was pulled out of the mines by mules. It was then hauled to the tipple, which facilitated the dumping of the coal into railroad cars or onto barges. Shown here is a more modern tipple, located near Carbon Hill. (Courtesy of Pat Morrison.)

Before mechanical tools, timber had to be loaded into mine cars by hand. The timbers shown here were used to prop up the roof at the Calimet Mine in Parrish. The company was owned by the Brilliant Coal Company. (Courtesy of the National Archives.)

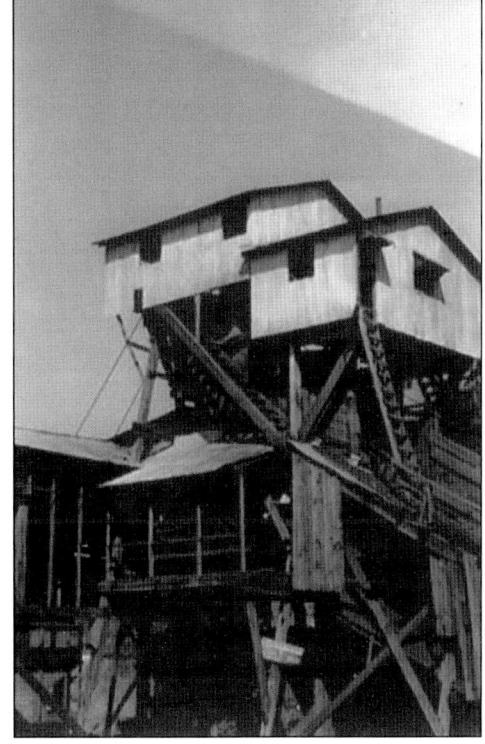

The Chickasaw Mine in Carbon Hill was initially owned by the Republic Corporation in the 1890s. Later, the Galloway Coal Company acquired the mine. In 1913, the mine produced 827,917 tons of coal. Almost 13,000 people were employed at the mines. (Courtesy of the New Deal Network.)

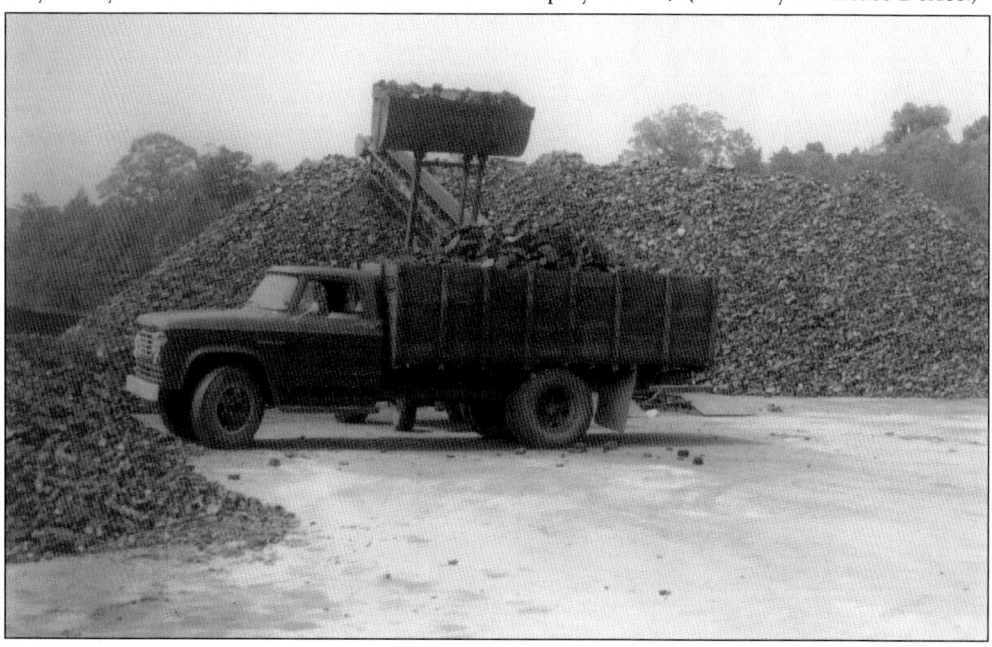

L.G. Bishop (center) of the DeBardeleben Coal Company attends the opening of the operation at Coyle. Coyle was located at the forks of the river in Sipsey in 1964. (Courtesy of Horace Defore.)

A front loader loads coal from a pile at the strip mine in Empire. The coal would later be transferred into trucks and sold. In 1967, when this photograph was taken, the price for a ton of real coal was $21.96. (Courtesy of Horace Defore.)

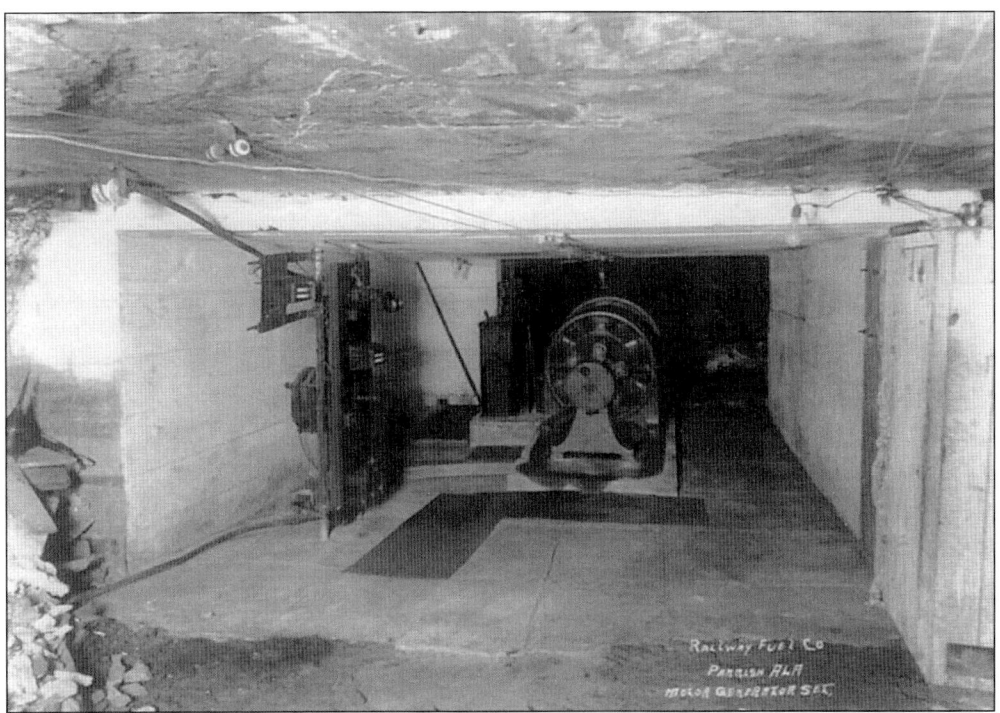
This is a look inside the Railway Fuel Company mine in Parrish. Note the electrical wires at the roof of the mines. Lightbulbs are manually wired into the sockets. (Courtesy of Horace Defore.)

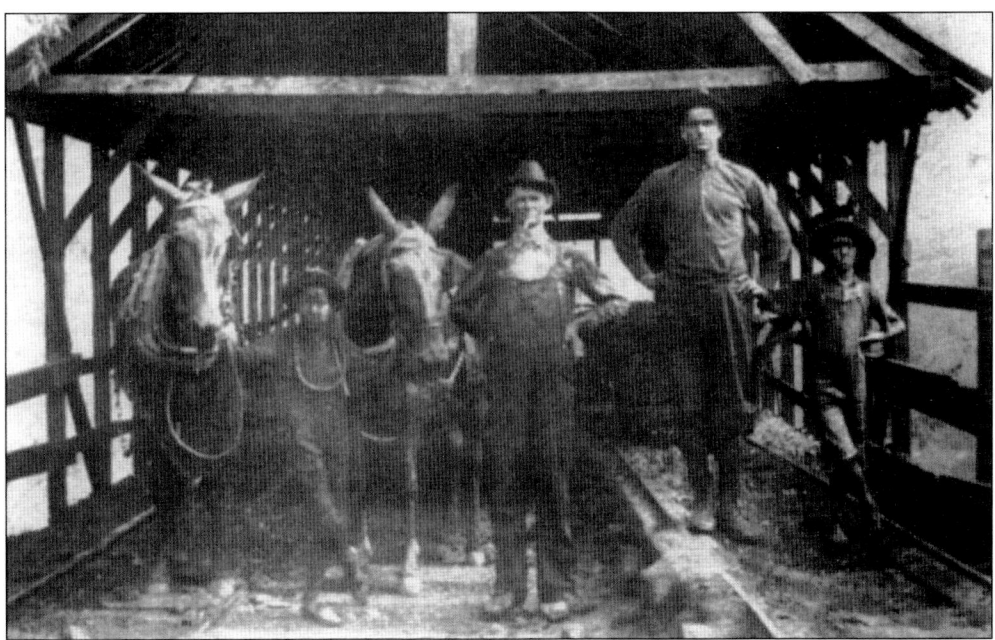
Nat Davis was an avid coal miner and a shrewd businessman. Not only did he work inside of the mines, but he owned and operated several mines around the Walker/Jefferson County area. From left to right are Davis, Lex Thomas, Robert Beck, and Sam Beck at the tipple at the old Victory Mine. (Courtesy of Kate Parks.)

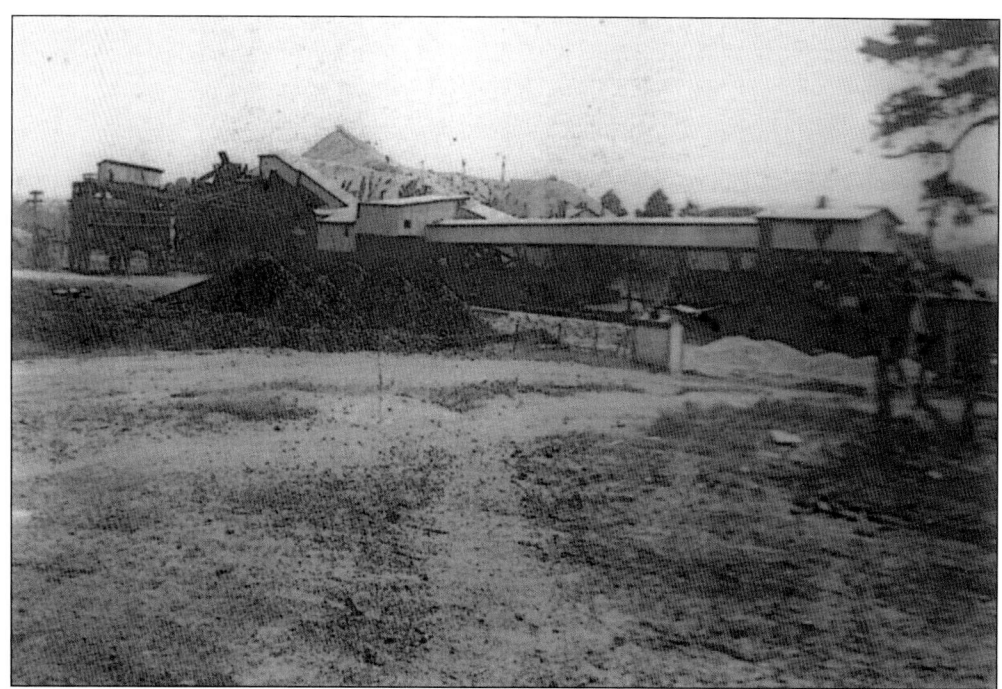
This mine is a familiar sight to those who live in Sumiton. The surface mine was located right off Highway 78 in the old Sumiton Mine community. (Courtesy of Horace Defore.)

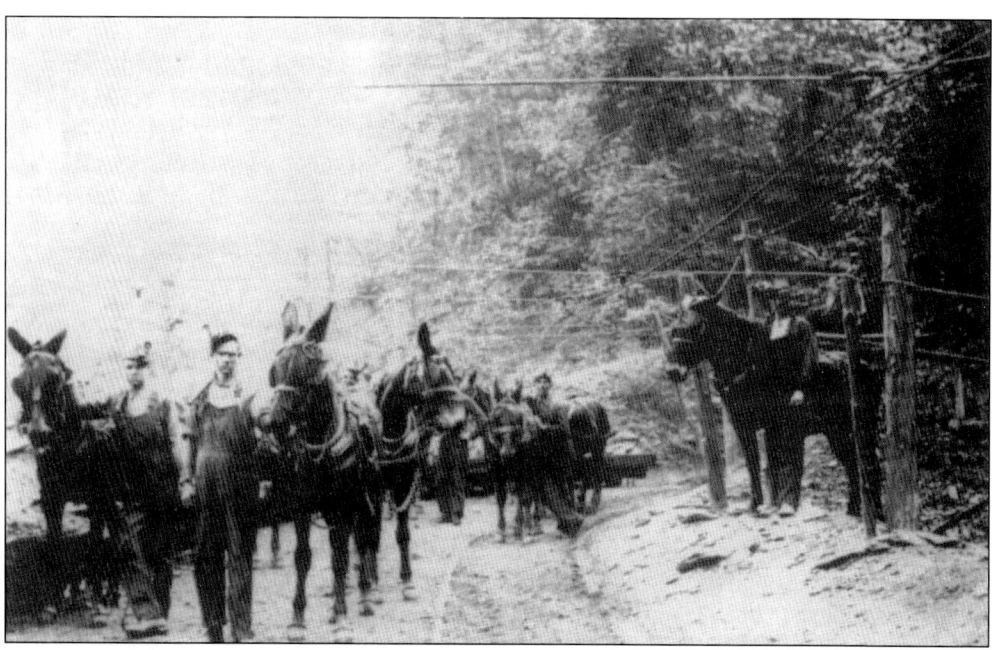
This photograph was taken at the Samoset Mine in Dora. Jim Gann, the father of James Gann, is the man at center leaning on the mule, which he rode to work each day. James Gann long served as the principal of T.S. Boyd School. The other men are not identified. (Courtesy of Horace Defore.)

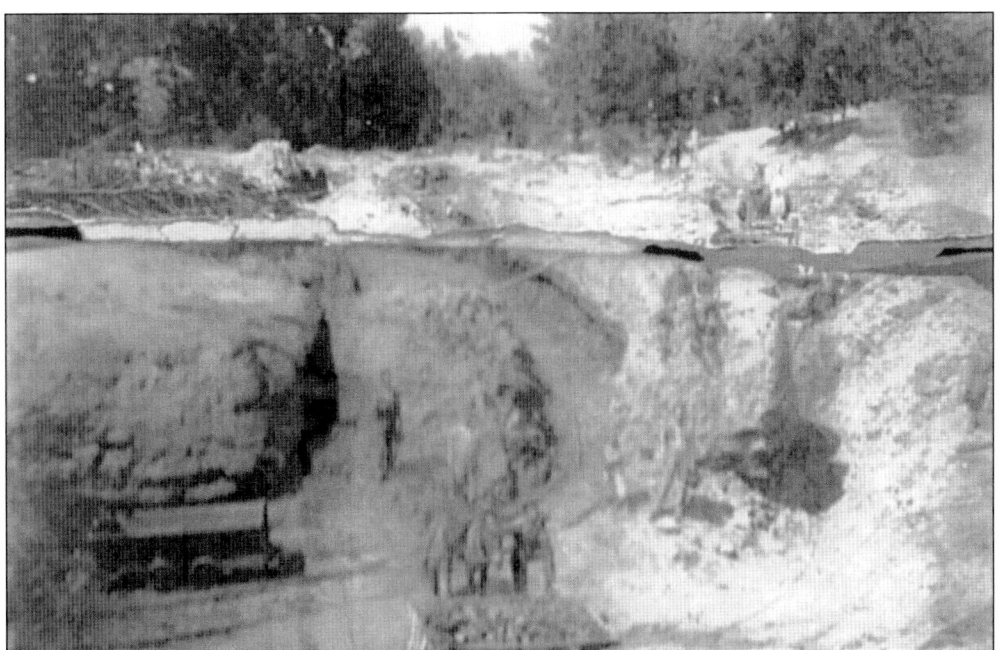

This is a rare photograph of the Sun Light Coal Company. The mine, a strip operation, began in 1915. It did not become an underground mine until 1927. It was serviced by the Alabama Central Railroad until 1940. The photograph, unfortunately damaged, shows the strip operation at the turn of the 20th century. (Courtesy of collectingalabama.com.)

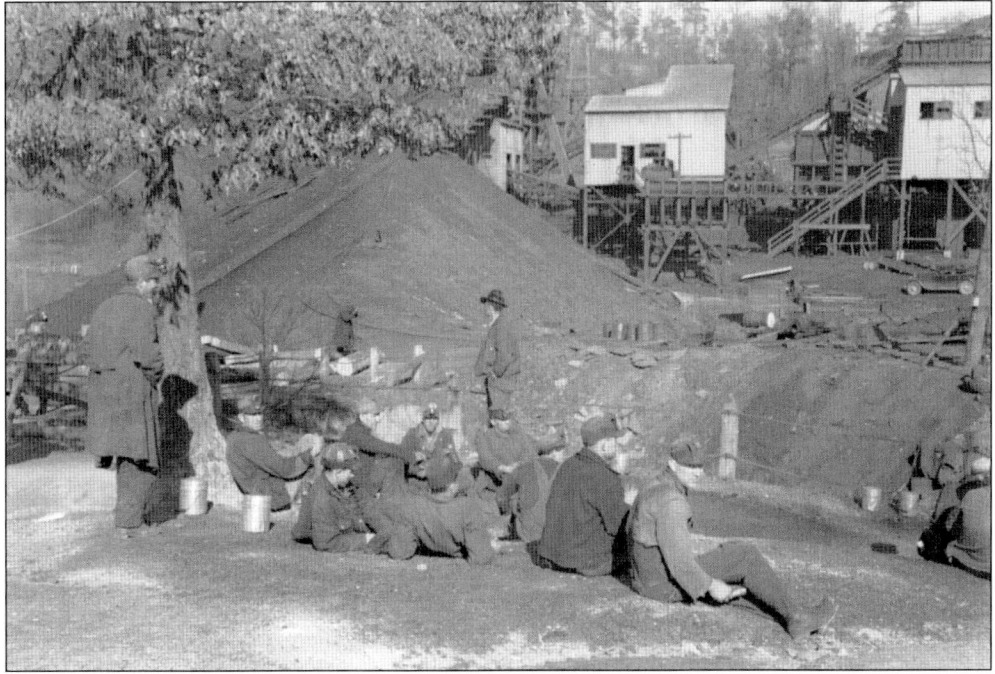

This is the Bankhead Mine near Jasper. It was owned by the Consolidated Coal Company. The miners appear to be on a much-needed break, perhaps for lunch, as their thermoses can be seen. (Courtesy of the Library of Congress.)

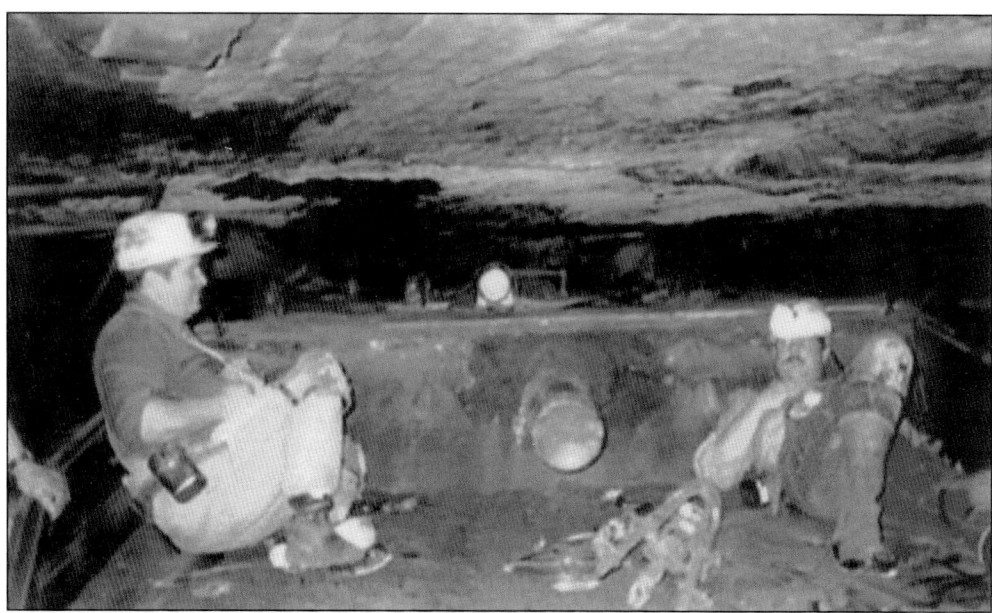

In this view of the Cedrum Mine in Townley, the strip pit is being mined. At the same time, the land around the pit is being reclaimed. In 1994, this dragline produced 1,024,210 tons of coal. (Courtesy of the Library of Congress.)

These miners are riding a ram in low coal at the Mary Lee Mines during the last few weeks that Mary Lee No. 1 was open. (Courtesy of Horace Defore.)

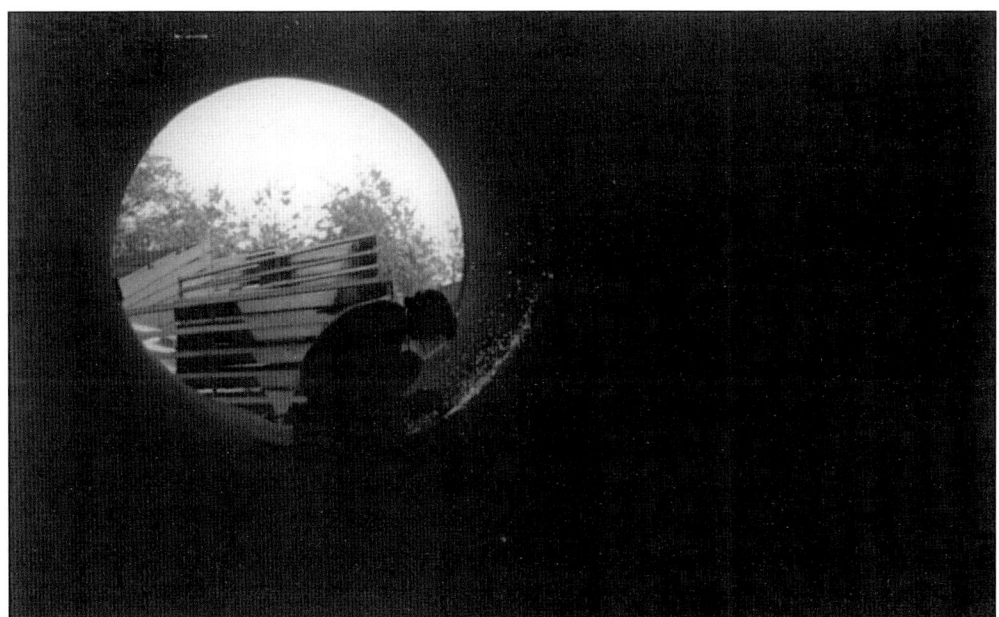

Here, a welder works on an air shaft at one of Drummond's mines. The air shaft plays an important role in underground mining, helping to keep outside air from mixing inside of the mines, which can cause an explosion. (Courtesy of the Drummond Company.)

This front loader is moving an air vent. Not only do air vents prevent air from mixing, but they help to regulate the air temperature inside of a mine. Underground mines have several air vents. (Courtesy of the Drummond Company.)

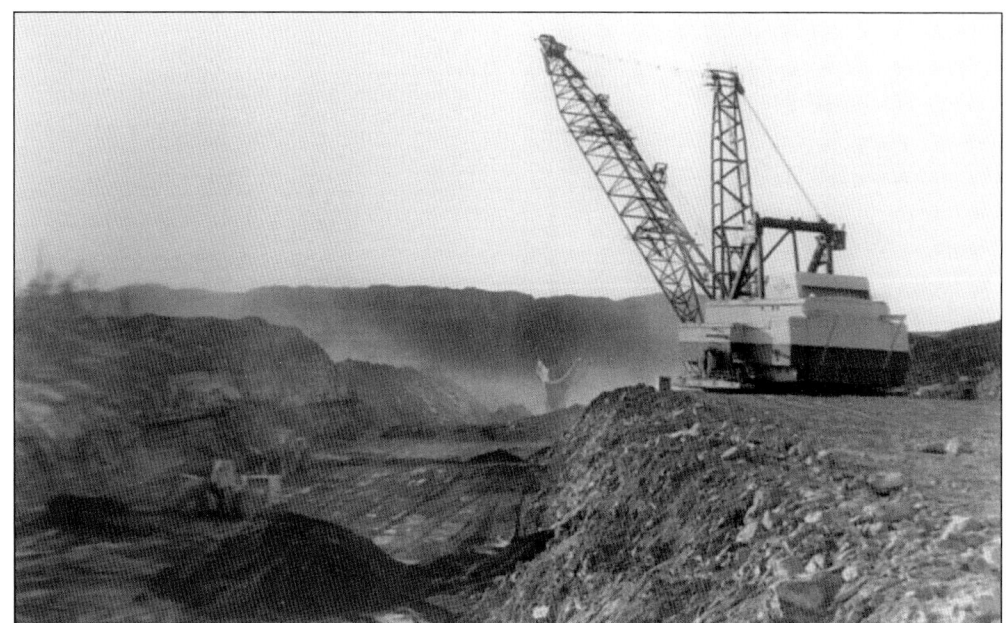

This dragline is the Heman II at Mill Creek, named after Heman Drummond, the founder of the Drummond Coal Company. Note the bucket and the boom. (Courtesy of the Drummond Company.)

This team has just exited the mine after inspecting an accident. Mine rescue teams respond to all types of situations, from rock falls to raised blood pressure. Note the man on the left works in low coal despite using a cane to walk. (Courtesy of the Drummond Company.)

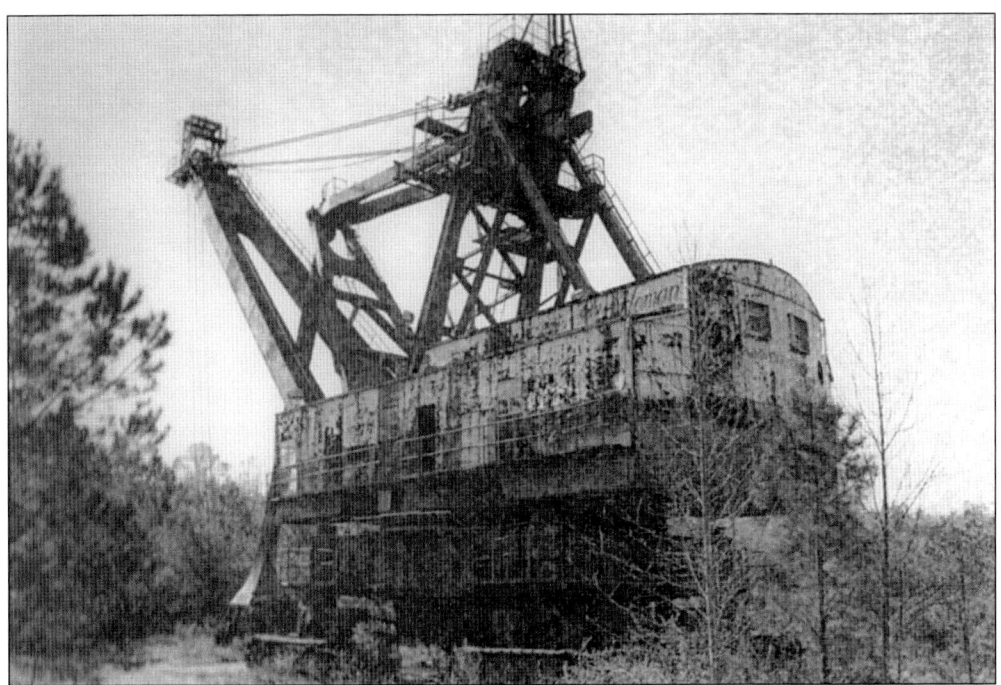

This rusty behemoth is the Drummond Company's Heman I dragline. The machine offers a glimpse into Walker County's coal-mining past. All of Drummond's draglines are sentimentally named. (Courtesy of the Drummond Company.)

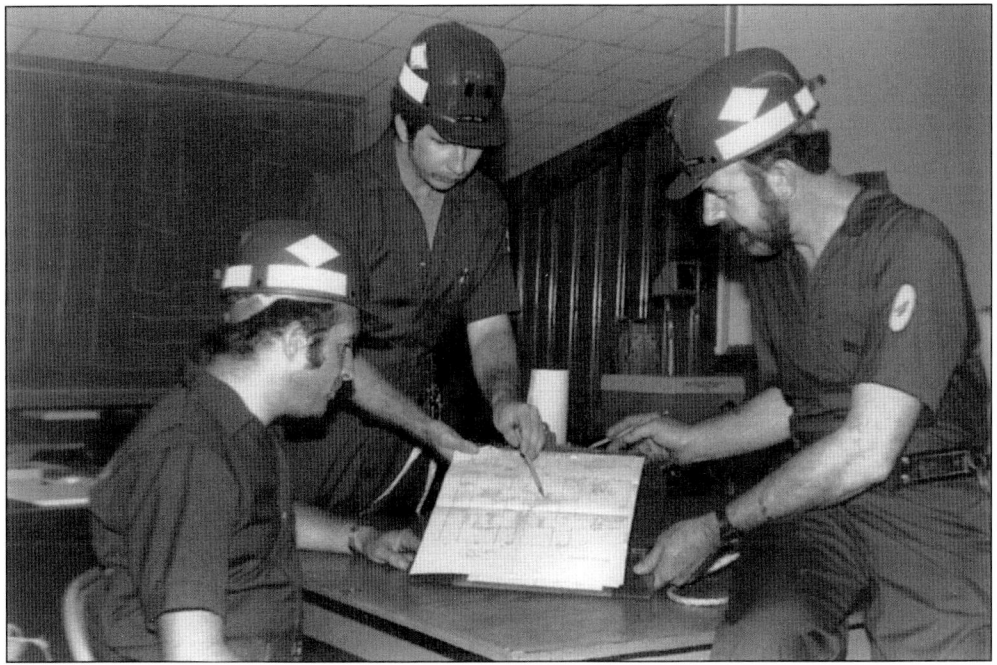

These foremen are going over the SEGCO mine airflow ventilation chart. Curtains and doors are used underground to keep air from mixing. (Courtesy of the Drummond Company.)

Work in the coal mines brought a wage that could not be matched in Alabama. This advertisement calls for workers for the Samoset and Barney Mines. Although the work was six days a week, earning $8 a day was better than average at that time. (Courtesy of the Drummond Company.)

This is a mine near Oakman. The portal and trolley can be seen, along with four miners. Oakman was a mine hotspot after the railroad came through the town. (Courtesy of Pat Morrison.)

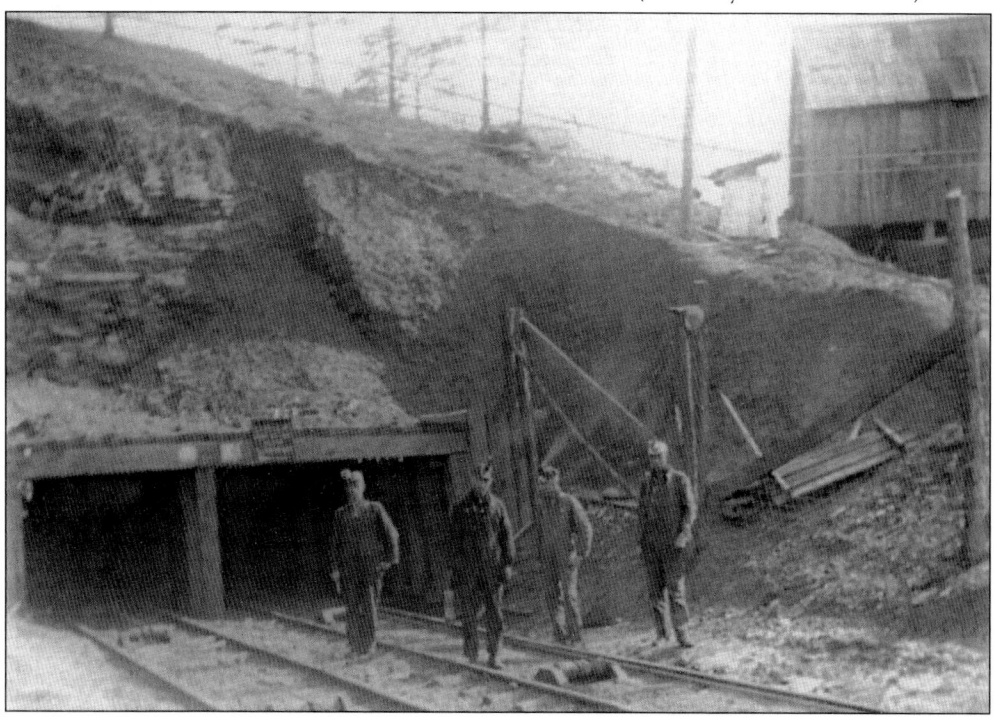

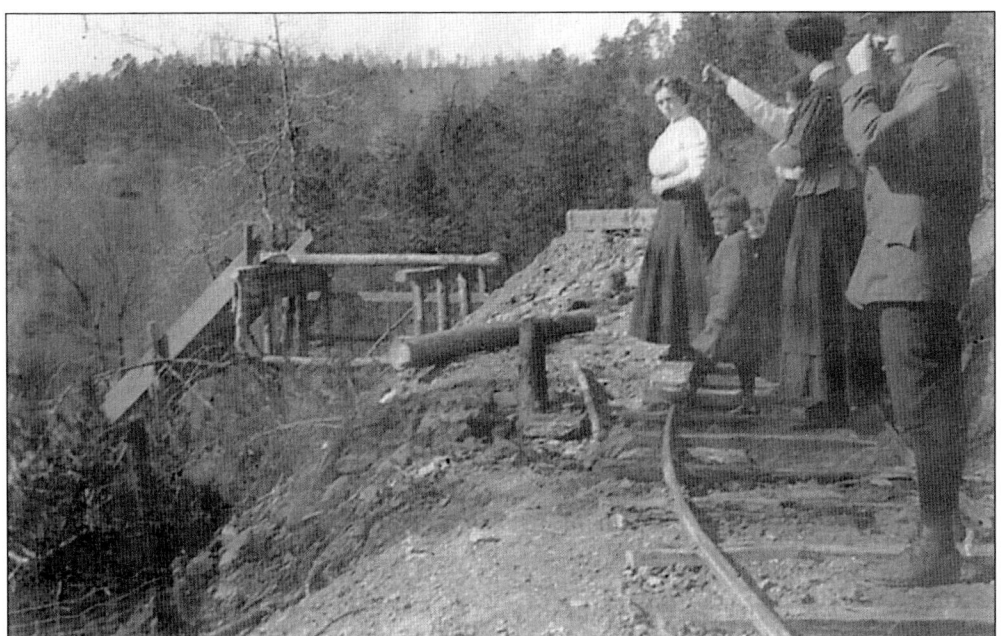

Here, the O'Rear Drifton tipple is being constructed. It looks as if the railway is going to directly attach to the tipple. The people inspecting the site are unidentified. (Courtesy of Pat Morrison.)

These miners, long-time employees of the Alabama By-Products Company, are preparing for their shift at the SEGCO No. 1 mine. Otis Bryant is on the far left. (Courtesy of Dot Daniel.)

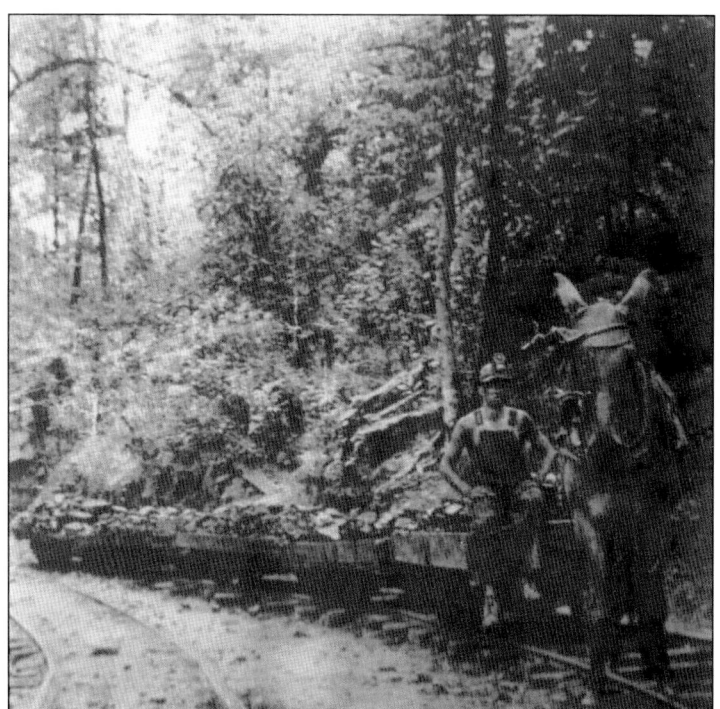

This photograph was one of the few taken in 1915. It shows a full wagon trolley of coal taken from a mine. The trolley is being pulled by a mule. (Courtesy of the Drummond Company.)

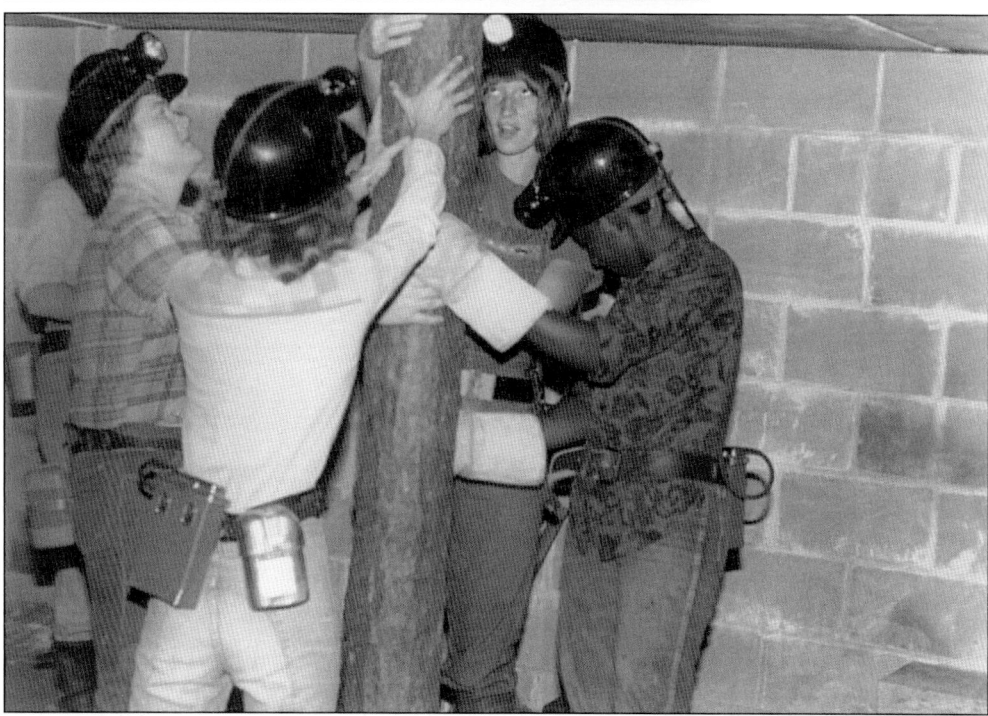

These women are learning how to install timbers in a mine at Bevill State Community College's simulated mine. The mining program at the school attracted both men and women. Through training, these women upped their chances of being hired at a local mine. (Courtesy of Bevill State Community College.)

Shown here is the washer plant at the Calimet Mine in Parrish in 1947. Coal washers increase the value of the product. When coal enters a washer, dirt, ash, and other impurities are removed from the material. The coal is then sent to be sorted. (Courtesy of the National Archives.)

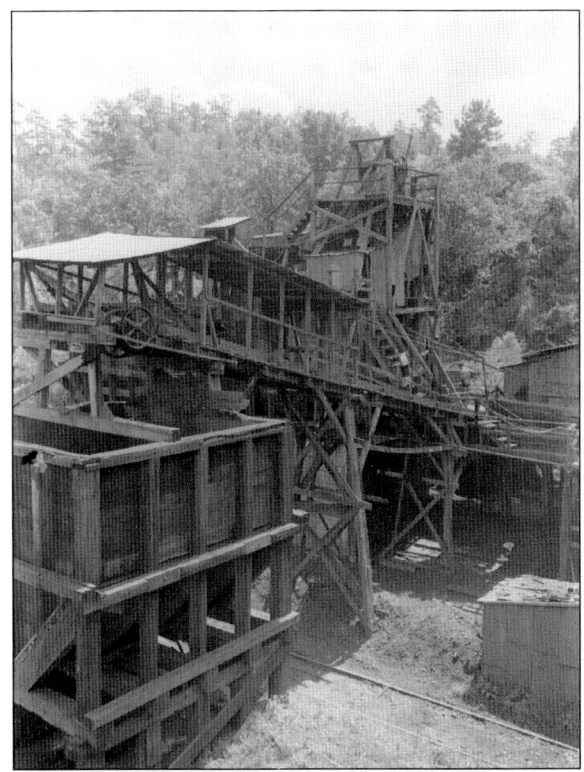

A miner at the DeBardeleben Mine in Empire removes temporary safety timbers from the ceiling. The timbers have to be removed so that the mining machine can move forward. After the machine clears the area, the timbers will be replaced. (Courtesy of Mine Safety and Health Administration.)

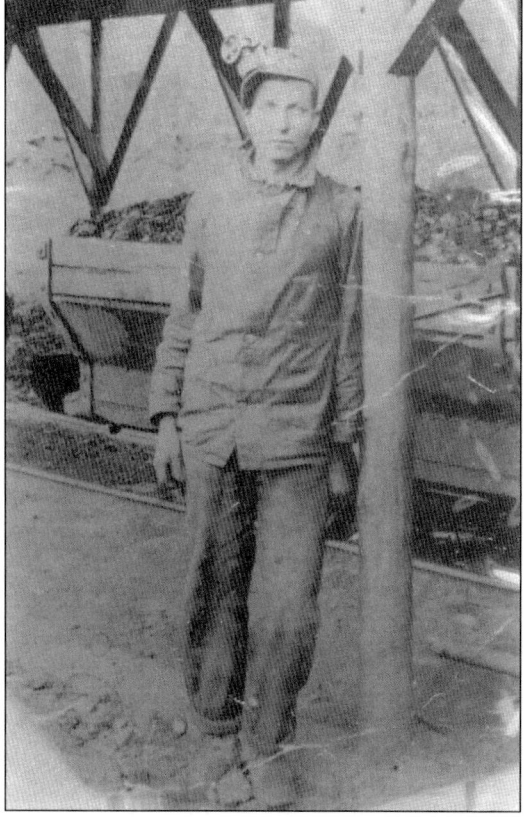

This is an aerial photograph of the Empire Mine and camp in 1967. That year, the railroad still ran to Empire to help transport the coal. The train tracks no longer exist today. Trucks were used daily to carry the coal to local buyers. (Courtesy of Horace Defore.)

William McDonald was 12 when he began working at the DeBardeleben Coal Mine in Sipsey in 1912. This photograph was taken that year in front of a coal car. Note his cloth hat, used in mines at that time. (Courtesy of Horace Defore.)

This is a bird's-eye view of the Sipsey Camp. Sipsey became a town after Henry DeBardeleben founded his mining operation. Henry Fies, an architect, designed the layout of the town, hoping to provide employees with everything they would want and need. (Courtesy of Horace Defore.)

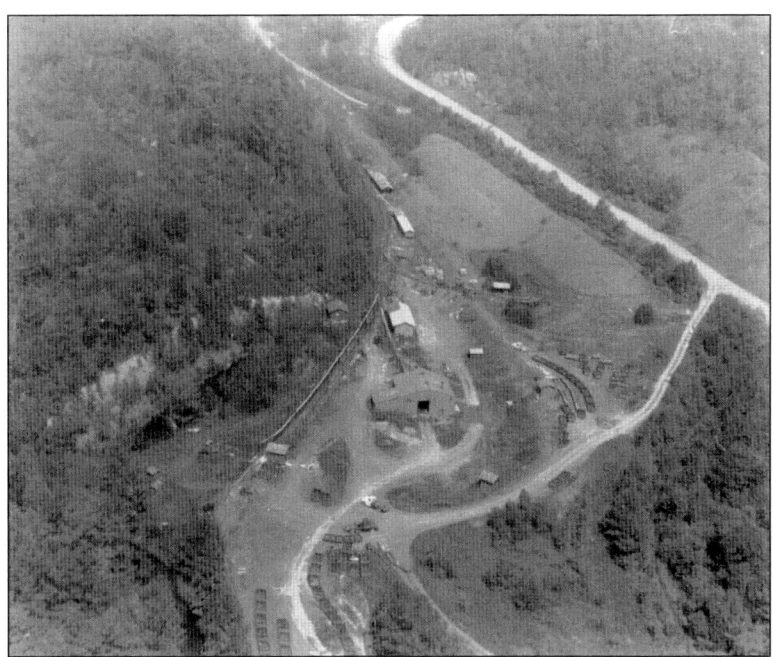

The bathhouse is a gathering hole for miners. It is also known for pranks. These miners pose outside of the bathhouse for a photograph at the SEGCO No. 1 mine. (Courtesy of J.D. Daniel.)

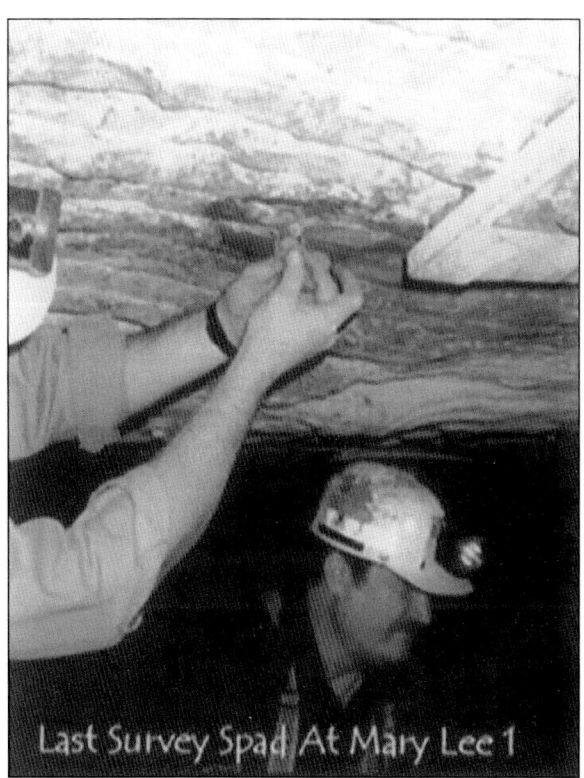

This is a photograph of the last survey at Mary Lee No. 1. This mine closed in the 1990s. Mary Lee was located in the Parrish/Goodsprings area. Today, the area is being strip mined. (Courtesy of Horace Defore.)

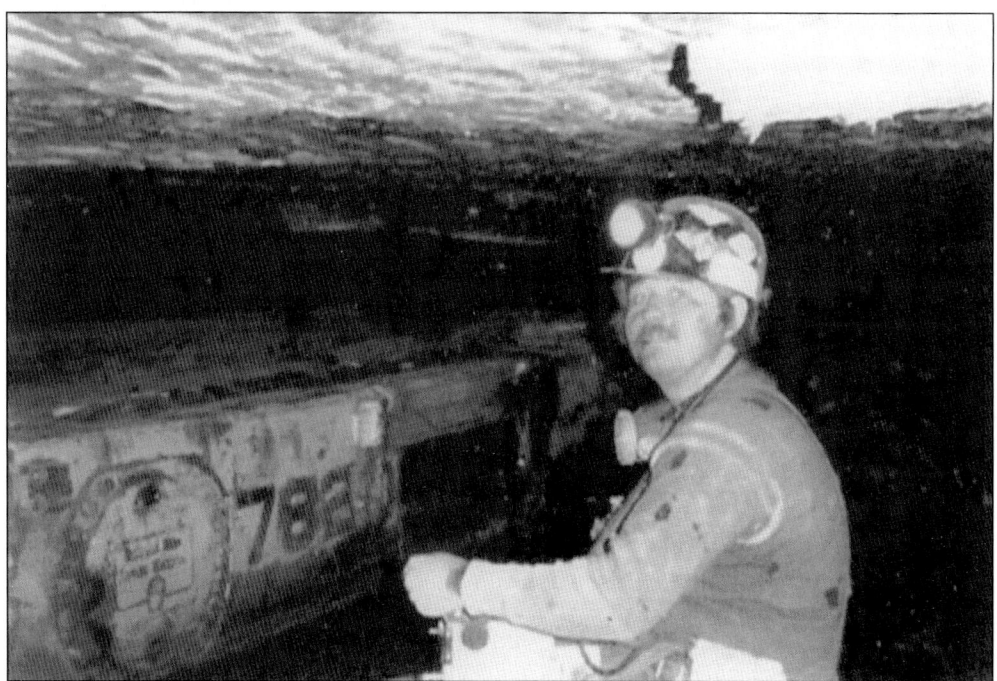

This photograph was taken at Drummond Coal Company's SEGCO mine. The coal seam is low, so the miner cannot stand. Miners in low coal stay hunched over for their entire shift. Note the mining machine in the background. (Courtesy of Horace Defore.)

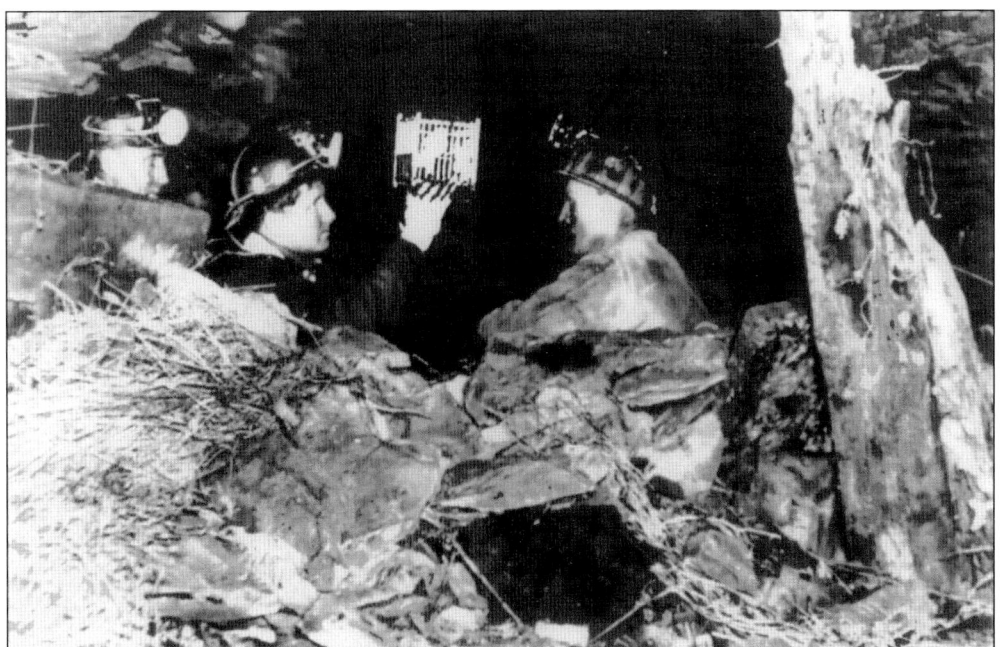

A coal-mining book would not be complete without a picture of a canary in a cage. These birds were used to detect methane gas. If the canary fainted or died, it was a cue for the miner to alert all of the other miners to "haul out of there," as one miner said. The canaries were used every day and during inspections. (Courtesy of Mine Safety and Health Administration.)

In this 1937 photograph of the Bankhead Mine, note all of the timbers, stored to be used inside of the mines. This piece of film must have been stored with a tack, which made the hole in the center of the photograph. (Courtesy of the Library of Congress.)

Here, a group of miners pose at the Flat Creek Mine. Located on the Walker/Jefferson County line, this mine was run originally by the Flat Creek Mine Company, but it is most known after Alabama By-Products purchased the mine. (Courtesy of the Alabama Mining Museum.)

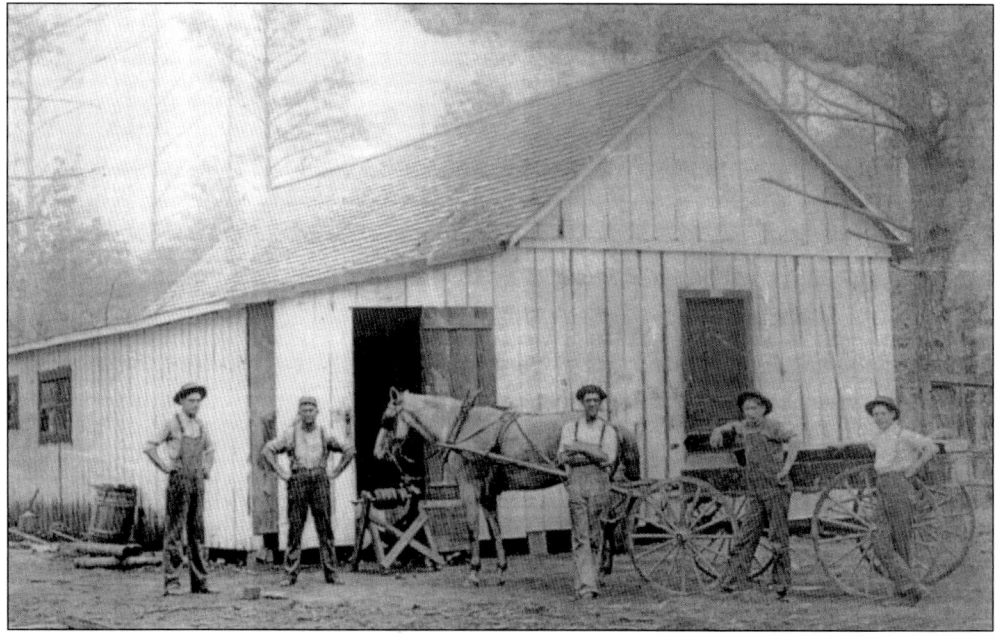

Flat Creek had several different mines. The camp consisted of everything a family needed, including a ball park. Here, men pose at a barn at the camp. (Courtesy of Pat Morrison.)

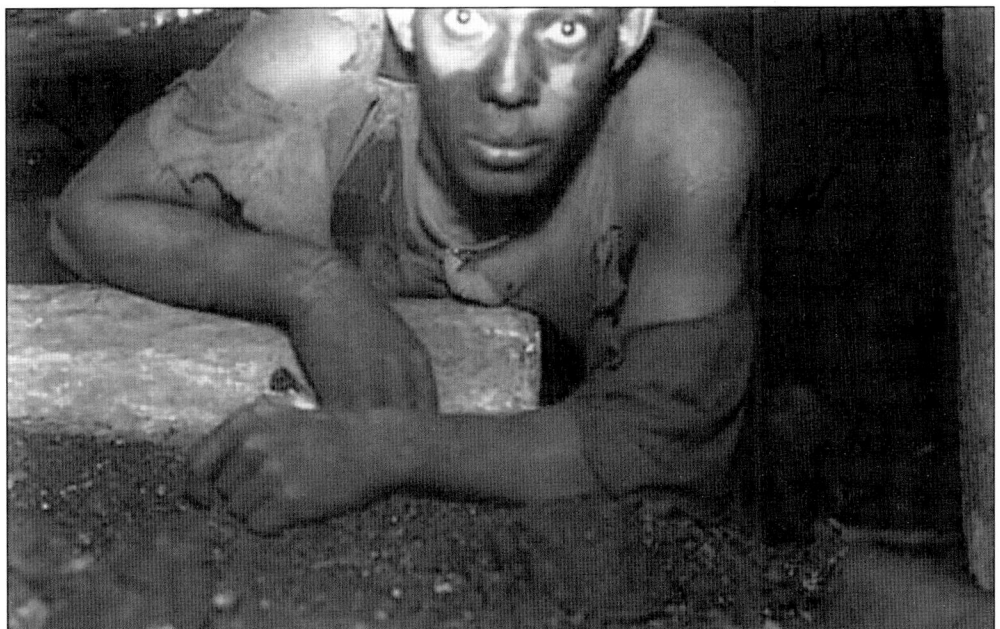
An unidentified African American miner is seen at the Chickasaw mines in Carbon Hill. The photograph was taken to record progress made by Franklin Roosevelt's New Deal. The government program completely revived the town during the Great Depression. (Courtesy of the New Deal Network.)

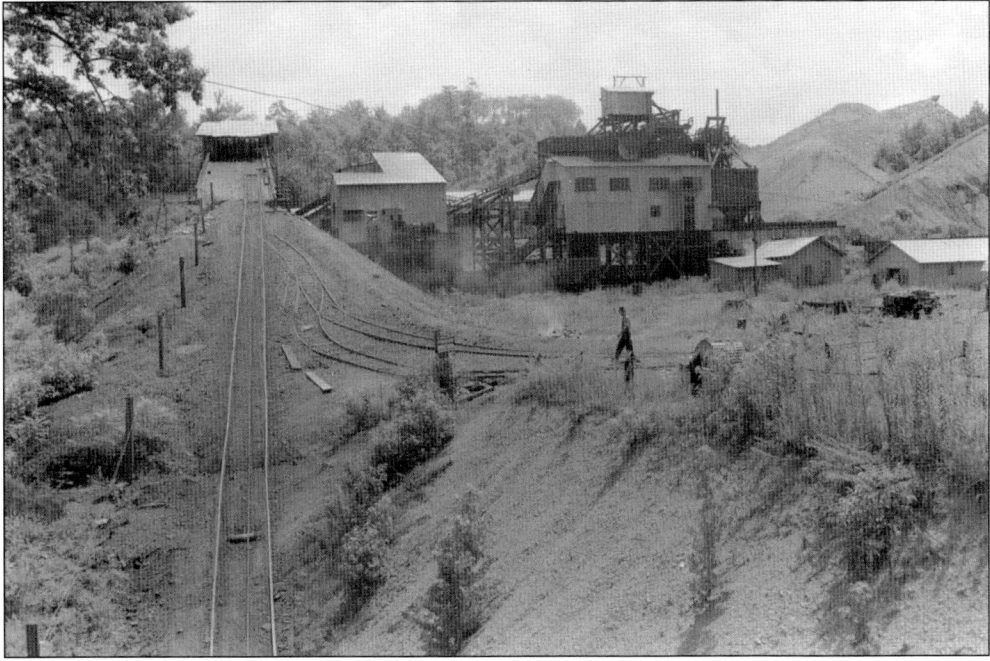
The tipple and slag beaks at the Bankhead Mine are seen here in 1946. The slag beaks cool the coal when it is burned. Water then crystalizes the coal remains. It is important to note that slag is not ash. The Bankhead Mine, like many mines, had its own coal generator operating the mine. (Courtesy of the National Archives.)

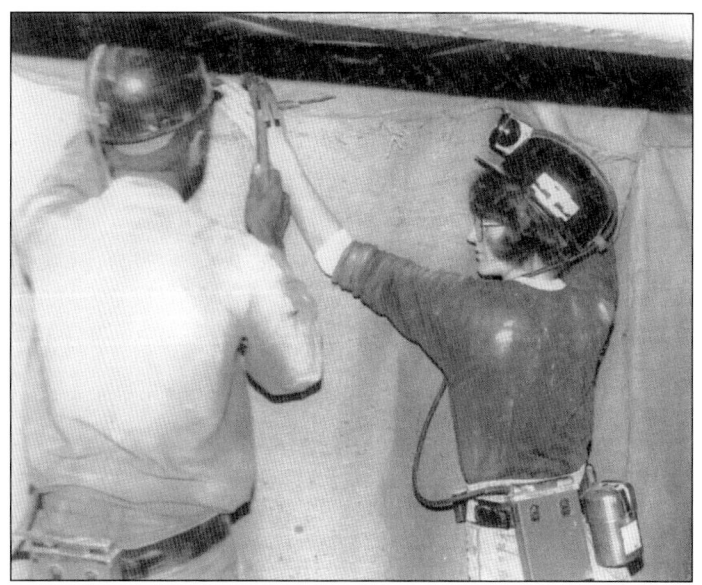

A female student of the mining program at Bevill State is learning to install curtains, which keep the mine's air from mixing. To complete training to become a mine foreman, a student must master the airflow blueprints. (Courtesy of Bevill State Community College.)

This photograph was taken at Mary Lee No. 2. Walter Holt (back row, far left) and the rest of the team are preparing to go underground. Mary Lee No. 2 produced 5,169 tons of coal per day and employed 521 underground miners. (Courtesy of the Drummond Company.)

The large pipe on the right is an explosion-proof air vent. Air from the mines is pushed into the vent, then travels into the large room. If the vent works correctly, when an explosion occurs, the room automatically opens two large doors on the roof of the building. This stops the airflow, thus stopping the fire. When the fire threat is over, the doors shut once again. (Courtesy of the Drummond Company.)

This is the Alabama By-Product mine office. The area to the right of the office is now a parking lot. On the left, under the pecan trees, is where retirees met annually for a reunion and picnic. The prep plant was used in 1985, when it prepared 627,152 tons of coal. (Courtesy of the Drummond Company.)

Jerry Ware worked at Maxine, which is on the Walker/Jefferson County line, and at Mary Lee No. 1. He is now retired from the Drummond Company. (Courtesy of the Drummond Company.)

Miners and officials review the mine blueprints at one of the Alabama By-Product mines. Note how vast the underground mine is. Underground mines can be miles long, with many pathways. Mining maps are a necessity in navigating coal tunnels and in enforcing mine safety. In this instance, an elevator cage had fallen with two men inside. (Courtesy of the Drummond Company.)

Coal from any of Drummond's mines is sent to the Tarrant Coke Plant. Mixing coke is a science in itself. The coal has to be tested, as does the final product. Coke products are rigorously regulated, making a lab a necessity. The final outcome of the product is used to make steel. Coke generates less smoke than bituminous coal by itself, increasing its demand when the need for steel is high. (Courtesy of the Drummond Company.)

Shown here is another aspect of the production of coke to be used for making steel. Water is dumped over the coke to cool it, creating the steam seen here. The Birmingham area was one of the few places that had iron ore, limestone, and coal to make steel. (Courtesy of the Drummond Company.)

Moving a 7.2-million-pound dragline is almost an impossible feat in itself, but to move the dragline across a river proved even more testing. But the Drummond Company managed to accomplish this task. The company wanted to move the Heman II to Mill Creek. Instead of transporting the dragline by vehicle, it proved to be easier to walk it to Mill Creek, near Smith Lake. The only problem was figuring out how to walk the dragline across the forks of the Sipsey River. The trip

took months to plan. A temporary causeway was built over the river, composed of 31,000 tons of rock. The trip to Mill Creek began on October 18, 1981. The Heman II was walked 17.49 miles. After the machine crossed the river, the temporary causeway was removed before the Heman II proceeded to its new home. It finally arrived 15 days later, on November 5. (Courtesy of the Drummond Company.)

The discovery of coal in Townley unleashed mining settlements that early residents did not expect. Mining began in the town in the late 1800s. This is a rare photograph of the Townley tipple. This postcard originally belonged to Ruth Teaford Baker, a local historian. (Courtesy of Pat Morrison.)

This is an interesting photograph of a mine-safety training session in the early days of the industry. Note the camp houses behind the miners. This must be a training exercise, because the miners are in nonwork attire. All that is known about the photograph is what was written on the back: Townley Mine. (Courtesy of Les Tate.)

Low coal, like this at SEGCO, is usually mined according to the coal seam. Miners have to work under a four-to-five-foot roof, depending on the seam. Many miners lie down, while some stay on their knees, depending on the job's requirements. (Courtesy of Horace Defore.)

This miner is setting a roof bolt. The machine to the left is drilling a hole into the roof of the mine. Usually, after the bolt is placed, a t-bar (so-called because of its shape) is inserted. (Courtesy of Horace Defore.)

Students compete in a mining competition at Bevill State Community College, which has an active mining program. Students have participated in mining competitions around the country. The college often hosts such competitions. (Courtesy of Bevill State Community College.)

This excellent photograph shows the inside of a mine. Note the Goodman cutting machine in the background. Goodman is a major manufacturer of mining equipment. (Courtesy of the Coal Wars Living History Project.)

The Maxine Mine was owned by Pratt Consolidated Coal Company, and later by Alabama By-Products. It was then purchased by the Drummond Company. In 1920, the mine produced 102,832 tons of coal. (Courtesy of the Drummond Company.)

The miner in the foreground is using an open-flame lamp, which was used before the development of electric lamps. These lamps were liable to ignite fires, from both methane and coal dust particles in the mine. The second miner is carrying a safety lamp, which is much safer. However, both of the miners are smoking inside of the mine. (Courtesy of Mine Safety and Health Administration.)

This is the Mary Lee Mine entrance. The mine was named after the Mary Lee coal seam, which runs through Walker, Jefferson, and Tuscaloosa Counties. In the 1980s, the seam accounted for 93 percent of the coal mined in Alabama. (Courtesy of Horace Defore.)

This loading machine is being used at the Empire Mine. The machine moves, and the arms on the front gather coal. Operators had to be careful, as there was always a chance of getting trapped between the machine and the rib, or the wall, of the mine. (Courtesy of Horace Defore.)

Everyone in Walker County knows about the long wait if a driver gets stopped by a train carrying coal to the Alabama Power Steam Plant, either at Gorgas or at Miller, right outside the Walker County line. No complaints here, though, as the power plant keeps electric prices low. Today, the coal used from the plants is purchased from South America. Alabama coal is used primarily in making steel. (Courtesy of the Library of Congress.)

Coal is loaded onto a barge at the Mulberry Forks of the Warrior River in Sipsey. This train was used to transport coal to ports in Mobile along the Warrior River. The Sipsey Bridge can be seen in the background. (Courtesy of Horace Defore.)

47

Here, pilots and members of the Bureau of Mines respond to a mining disaster in Carbon Hill. (Courtesy of Mine Safety and Health Administration.)

Bill Lockhart and his daughter Betty Sue pose at the Jake Phillip Mine. It is believed that the DeBardeleben Coal Company owned the mine at the time. Note the wash bucket in front of the house. (Courtesy of Horace Defore.)

The simulated mine at Bevill State Community College is equipped like an actual mine, including curtains, props, simulated heights of coal, and air vents. Students learn everything about a mining operation, from belt installation and rock dusting to track installation and rib ventilation. (Courtesy of Bevill State Community College.)

Don Blaylock (right) demonstrates how to use an artificial respirator in a medical emergency. The respirator is used by the mine-safety team to help revive miners. (Courtesy of the Drummond Company.)

The O'Rear-Drifton Mine began operations in 1911. The first company officials were Earnest Lacy, Caine O'Rear, and Guy O'Rear. As seen here, both African American and white miners of all ages were employed at the mine. The O'Rear-Drifton Mine was located near Parrish, Alabama. George O'Rear, who was elected county sheriff, was accused of mistreatment of workers. He vehemently denied the charge, but resigned from office. (Courtesy of Pat Morrison.)

The hard task of loading coal by hand into a coal train is depicted here. The mules hauled coal to the train, where miners then loaded the coal. It was not uncommon for workers to shovel coal for 10 hours straight. Sometimes, miners worked even longer hours. (Courtesy of Pat Morrison.)

This photograph shows an outside shop at one of the Drummond mines. A lathe is being used to carry a steel beam. (Courtesy of the Drummond Coal Company.)

Kneed pads, such as those worn by the man on the left, were a lifesaver for miners who worked in low coal. This photograph illustrates the camaraderie that exists underground. In a mine, workers depend on each other. This photograph was taken at the SEGCO Mine in the 1980s. (Courtesy of the Drummond Company.)

Seen here in 1982 is the mine-rescue team at Bevill State Community College. The team is called in to assist at mine disasters across the country. The members are, from left to right, (first row) Scott Miles, Charles Sparks, and Kenneth Russell; (second row) Ron McCarty, Kenneth Knight, Vince Weeks, and Wayne Lollar. McCarty, one of the original members, said that his involvement has taught him to appreciate the courage of rescue teams. (Courtesy of Bevill State Community College.)

This is another photograph of the high wall and dragline at Empire Mines. The dragline may look small, but it actually weighs several tons. (Courtesy of Horace Defore.)

Here is the mine opening at the Pratt Fuel Company in Dora. The mine was located on West Pratt Road. Charles Blackman (pictured) worked in many of the mines around Dora, Alabama. He also worked at the Kershaw Mine, which was named after mine operators, and the Sloss-Sheffield Mine. (Courtesy of Horace Defore.)

Angus Ballenger (right) worked as a blacksmith in the No. 6 mine. This mine was located next to Fire Tower Road. (Courtesy of the Alabama Mining Museum.)

The importance of truck sales is indicated on this sign. At the time of this photograph, coal was still used in many rural houses as fuel for heat and cooking. While most of the money was made in large shipments, independent buyers provided a steady income for smaller mines. (Courtesy of the Library of Congress.)

In 1943, Heman Drummond put his mules Ole Tobe and Lowe, along with another mule, up for collateral for a $300 loan to start his mine at Sipsey. Today, the company has grown into a multi-million-dollar firm. Ole Tobe was honored for his sacrifice when two different draglines were named after him. (Courtesy of the Drummond Company.)

Workers pose at the Coal Valley Mine, which was located between Townley and Oakman. Note the young boy in the photograph. Pierre F. Laurent, 14, moved to the area with his family. This photograph was taken at the No. 7 hollow, behind the mining camp. (Courtesy of Pat Morrison.)

Seen here is the Railway Fuel Company in Parrish. The photograph shows a more modern mining operation. (Courtesy of Pat Morrison.)

James Brown (left) was a well-liked and well-known superintendent at Mary Lee for many years. Here, he accepts an award presented to him by Randall Green from all of the Mary Lee union employees. (Courtesy of the Drummond Company.)

A powder house is where mine operations stored all of the powder used for dynamite. The pipes coming out of the building provide ventilation, necessary to prevent explosions. (Courtesy of the Drummond Company.)

This photograph of an old locomotive was taken at the Pratt Consolidated Mine at Maxine mine. Notice the coal underneath the trestle. Pratt was the first commercial company to ship coal down the Warrior River to Mobile for sale. The shipment from the Maxine mines opened up the Birmingham market to foreign buyers. (Courtesy of the Drummond Company.)

The Ruby Mine in Cordova once employed many people. The mine in 1910 had a capacity of 250 tons of Horse Creek coal daily. The operation had a large mining camp, where the miners lived with their families. (Courtesy of Pat Morrison.)

This is the Sloss tipple in Kershaw Hollow, located at the No. 3 Mine. It was operated by the Sloss Steel and Iron Company and later by Sloss-Sheffield Steel and Iron Company. (Courtesy of Rick Watson.)

Heman Drummond opened his first mine in 1934. By the following year, he was making enough money that workers could unionize. Earnest Baggett was the president of the local at the time. This is the original document for the mine, signed on October 10, 1935. At this time, many mines were fighting the unions, but Heman Drummond welcomed them. The document was signed by the great John L. Lewis himself. (Courtesy of the Drummond Company.)

This famous photograph of Shorpy Higginbotham was used by child-labor advocates at the turn of the 20th century. Although this photograph was taken at Bessie Mines, just outside of the Walker County line, Higginbotham has a Walker County connection. He was born in Nauvoo, and his family moved to Bessie to work in the mines. He is buried at Lynn's Crossing. (Courtesy of the Library of Congress.)

Workers pose at the Coal Valley mines, which was a hot spot for the union wars in the 1930s. After a bridge was blown apart and two sheriff deputies were killed, the sheriff wrote to the governor, asking for the National Guard to be stationed around Coal Valley. It was months before order was restored. (Courtesy of Pat Morrison.)

This is the washer at the Brilliant Coal Company's Calimet Mine in Parrish. Washer plants are important to coal sales. In a washer, the dirt, soil, and other minerals are separated from the coal. Most of the time, the coal is either separated into different sizes or is crushed in order to be sold. (Courtesy of the National Archives.)

At one time, coal mining was encouraged by the government. During World War II, coal was used to power locomotives, to warm soldiers, and to make steel. These posters were placed in coal mines to remind workers that it was their patriotic duty to mine coal. If coal miners went on strike, it was deemed a disservice to the country at that time. (Courtesy of the Library of Congress.)

This photograph marks a great moment in the history of the Drummond Company. This is the first electric motor that Heman Drummond purchased in 1956. He proudly stands at left. With him are James Hannah (center) and Henry Drummond (right). A close look reveals Roy Cleveland on the dozer. (Courtesy of the Drummond Company.)

This is a photograph of the SEGCO mine rescue team in the late 1970s. The team has responded to many disasters. In 1977, a rock fall led to the death of one man. Another man, Otis Bryant, who the retirees call "the miracle man" was spared. A man dug a path to Bryant. After grabbing onto his overalls, another grabbed onto his boots, the next grabbed his boots, and so on, until Bryant was pulled out from under the rock fall. (Courtesy of the Drummond Company.)

Heman Drummond is seen here in the 1950s, in one of the last photographs taken of him at the mines. He passed away in 1956. His mine, which started with a few mules, had over $1 million in sales at the time of his death. (Courtesy of the Drummond Company.)

Steamboats not only used coal in their operations, but they towed the material down the Warrior River. The river, seen here in 1915, has been a commercial thoroughfare since settlers first came to the area. (Courtesy of the Drummond Company.)

Claude Campbell (pictured) worked at the Chickasaw Mine in Carbon Hill. He poses for a photograph to commemorate the achievements of the Works Progress Administration (WPA). Carbon Hill was hit hard by the Great Depression. Miners were often laid off, making the WPA a welcome program. (Courtesy of the New Deal Network.)

Seen here is Ed Sherriff and another worker from the Mary Lee No. 2 mine. Mary Lee No. 2 was a long-operated mine. Mary Lee No. 1 and No. 2 were both named after the Mary Lee coal seam. Several different coal seams are located in Walker County. (Courtesy of the Drummond Company.)

Robert Bice and J.D. Daniel are shown exiting the SEGCO mines. Both men were among the first hired at the mine, and they were among the last to leave when the mines ceased operations. (Courtesy of SEGCO retirees.)

Pious Ballenger worked at mines around Dora. Note the whip hanging around his neck, which he used on the mule. His lunch box was a common sight among miners. A thermos was filled with water and placed at the bottom of the lunch box. This kept food cold. Miners had to take everything they would need with them underground. (Courtesy of Pat Morrison.)

65

A continuous miner is used to dig coal from the coal seam. It bores holes into the seam and then moves back and forth to break up and move coal. (Courtesy of the Drummond Company.)

The Gorgas Fossil Fuel Plant, built in 1917, was the first in Alabama. The plant was one of the reasons the Warrior River was dammed. The original intention was to house a mine on the property to mine coal that would, in turn, power the plant. (Courtesy of the Library of Congress.)

This is an aerial photograph of the Gorgas Steam Plant today. The plant has undergone many changes since it was built. Today, the plant burns coal and uses scrubbers to reduce its carbon footprint. (Courtesy of the Library of Congress.)

Although mining equipment has changed over the years, some things remain the same. Miners still go underground with everything that they need for the day. This unidentified miner carries his lunch box and boots after working a long shift. (Courtesy of the Drummond Company.)

This photograph of an alpine miner was taken around 1950. Other than employing more safety precautions, miners today are not much different from their predecessors. This photograph was taken at a mine near Dora. (Courtesy of Pat Morrison.)

Coal dust is an inevitable fact of life for miners. The dust gathers around the eyes and even in the ears. Here, miners wash off their boots after exiting the mines. (Courtesy of the Drummond Company.)

This is a famous photograph of the coal tipple at DeBardeleben in Sipsey. The mining camp at Sipsey once housed 900 workers, not counting all of the mine and mining-camp employees. This photograph was taken in 1917. (Courtesy of Horace Defore.)

These miners are exiting the SEGCO No. 1 mine after a long shift. The SEGCO mine produced around 1,800 tons of coal a day and closed in 1985. (Courtesy of Dot Daniel.)

These two women are studying in the simulated mining building at Bevill State. Many women have graduated from the program. (Courtesy of Bevill State Community College.)

These Gorgas miners exited the mine to meet a visiting official. Gorgas was owned by Alabama By-Products and was later acquired by the Drummond Company. It was then called ABC, to avoid confusion. (Courtesy of the Drummond Company.)

This miner is working on a continuous belt line, which hauls coal outside of the mines. The machine's name is self-explanatory. (Courtesy of the Drummond Company.)

This photograph illustrates the manner in which coal is loaded into cars. The coal travels up the conveyor belt and into the stacking tube, where it is separated and placed into coal cars. This mine was not in Walker County, but was right along the county line. (Courtesy of the Drummond Company.)

Shown here is the inside of the Empire No. 3 mine. The t-boards in the ceiling help to support the roof. These miners seem to be using trolley wire. (Courtesy of Horace Defore.)

This miner is underground at the Mary Lee mine. He is riding a scoop, which is used to pick up coal and haul materials to the seam. The coal dust is not keeping him from blowing bubbles with his gum. (Courtesy of the Drummond Company.)

This is how miners installed a roof bolt in the era before today's machines. The miners used a device to bore a hole. The bolt was then drilled into the roof. (Courtesy of Mine Safety and Health Administration.)

The Ole Tobe dragline was named after the faithful mule that Heman Drummond used as collateral for his first mines. All of the Drummond draglines are sentimentally named. (Courtesy of the Drummond Company.)

These miners are looking at the tailpiece of a long wall. The jacks in the foreground are inserted into the roof and wedged, making the structure safe. (Courtesy of the Drummond Company.)

Miners at Mary Lee No. 1 exit the cage after a shift. The cage is the elevator that takes miners underground. Mary Lee No. 1 closed in 1997. (Courtesy of the Drummond Company.)

Mining foremen use plans to install air ventilation and electrical wiring and to implement coal quotas and safety features. These miners are creating the plan for their shift. (Courtesy of the Drummond Company.)

The Galloway Coal Company office in Carbon Hill is a Walker County landmark. The company moved its mine office to the center of Carbon Hill to encourage miners to shop in the community. A line would form outside the door on payday. (Courtesy of Pat Morrison.)

Townley was once a thriving coal community. Nearby Holly Grove was one of the first places where families began to settle. Shown here is the Cedrum strip-mining operation in Townley. (Courtesy of the Library of Congress.)

L.G. Bishop, an official with the DeBardeleben Coal Company, is seen here in the 1960s opening a strip operation at Coyle, at the forks of the river at Sipsey. (Courtesy of Horace Defore.)

This is a receipt from the Drummond Company for coal in 1967. The cost of the coal was only $7.50 a ton. The receipt shows the different types of coal, which are sold as nut, lump, egg, and stoker. These types of coal are processed at a coke plant. (Courtesy of the Drummond Company.)

The Sloss Mine in Dora opened in 1891. It was a big enterprise, and many locals were employed at the mine. This is a photograph of its gigantic tipple and crusher. A new tipple was built in the 1920s, but was never used due to the mine closing. (Courtesy of Rick Watson.)

77

A young man poses for the camera in 1918. Note his cloth hat and mining light. Cloth hats were used in the early days of mining, before mine safety began to grab the national spotlight. It was not until 1942 that the US government was given authority to inspect mines and mining conditions. (Courtesy of Mine Safety and Health Administration.)

The McDonald Mine in Carbon Hill was run by the Great Elk Company. Here, citizens have gathered on the tracks. (Courtesy of the Alabama State Archives.)

In 1944, Alabama Power, Pratt Coal Company, and the US government developed a plan to gasify coal underground to power the Alabama Power Plant at Gorgas. The operation was run by Henry Fies of the DeBardeleben Coal Company. It was the first time the project had been tried in the United States. During the experiment, 256 tons of coal were completely consumed. Here, rock dust is being blown from the wall near the audit, or lowest opening possible, of the mine. (Courtesy of the University of North Texas.)

While most mines dust rock to keep a fire from happening, in this experiment, rock dust was blown by air-blasting, which was meant to set off small explosions. This process is called direct blowing. Here, small cracks made in the gunite from the blast can be seen. This is a photograph of the furnace used in an experiment to depict what will take place in the underground mine. A close look reveals the foam-like slag created from the coal after it was heated. The cray was created by the cap rock. The outcome of the experiment was that the rock fractured. (Courtesy of the University of North Texas.)

This photograph shows the inside of the mine. Bags of clay were carried into the mine to place in front of the concrete stoppings, which were used to stop the spread of a fire. Steel timbers were used instead of the traditional timber ones of that era, because they melt at a much higher temperature. (Courtesy of the University of North Texas.)

After years of preparation, the mining experiment began in January 1947. Thermite bombs were planted inside of the mine. Another thermite bomb was placed into a drill hole. This bomb ignited the other bombs. Three other bombs were also dropped. At first, black smoke began to emit from the stack. Eventually, the smoke died down, emitting gas. The gas temperature was recorded and the gas was sampled. Other procedures, such as reverse blowing and oxygen blowing, were tested. Fifty days later, the experiment came to an end. The hope was to find a cheaper way to mine deep, low coal beds, and the experiment worked. (Courtesy of the University of North Texas.)

Two
Mining Life

This is the inside of the bathhouse at Calumet Mine in Parrish. The room has a coal-burning heater. The individual showers seem to be primitive, but many rural residents did not have indoor plumbing at this time. (Courtesy of the National Archives.)

This receipt from the Empire Coal Company is a stark reminder of the dangers of working in a mine. Apparently, in 1915, a prosthetic leg cost $75. (Courtesy of Horace Defore.)

Coal camps had their own theaters. Shown here is the theater at the Empire Mine. There was always a noon and evening show for miners, or their families if they were working. In the 1920s, the price of a movie was around 7¢. It was a nice way for families to unwind. (Courtesy of Horace Defore.)

The exact location of this mining camp at Lost Creek is not known. (Courtesy of Pat Morrison.)

A.T. "Bad Eye" or "Bat Eye" Tuggle was a company deputy. This photograph was taken at Consolidated Coal Company's Bankhead Mine. Tuggle was a deputy for many mining companies throughout his life. He was infamous among union members. (Courtesy of the National Archives.)

This is a receipt for a car of coal from the McDonald Coal Company in 1897. It is interesting that a car of coal was only worth $1.10. A lot of work went into digging coal. At the time, it was done mainly by mules and picks. (Courtesy of Pat Morrison.)

The SEGCO employees have kept a close brotherhood. The SEGCO mine provided a good, middle-class income for workers until it closed. Here, retirees are shown shooting the bull. (Courtesy of J.D. Daniel.)

Magellan Bottoms was one of the first mining camps in the county. Built by the Pratt family before the turn of the 20th century, it was located right off Horse Creek Boulevard in Dora. (Courtesy of Lucille Singleton.)

Baseball games were competitive and were a favorite pastime among miners and families. The game shown here is being played at the Gorgas Mine. Mining companies often hired workers based on their athletic ability. Rivalries between different mines grew, and companies would try to out-recruit one another. Several members of mine-company teams went on to national baseball fame. (Courtesy of Pat Morrison.)

Strikes were common, a result of disagreements over wages and hours. This is a UMWA march in Parrish. Anyone who crossed a picket line was deemed a scab. Mining companies would often go to Northern cities and to immigrant ports, such as Ellis Island, to recruit workers during strikes. (Courtesy of Horace Defore.)

When architect Henry Fies designed DeBardeleben Sipsey's camp, he wanted mines to be self-sufficient. For example, a dairy was provided for mining families. Fies believed that, if miners were provided with everything they needed, production would increase. Miners with families paid $1.37 a month for the dairy service. (Courtesy of Horace Defore.)

Clacker was given to miners to use in company commissaries, to be redeemed for whatever they needed. Clacker was both good and bad. Companies had items for sale that miners might not normally be able to purchase in rural areas. Of course, many miners could never crawl out of debt of the mines. Shown here is clacker from the Fowler Coal Company in Carbon Hill, Alabama, By-Products at Barney, and Gayosa Mine near Oakman. (Courtesy of collectingalabama.com.)

Months, sometimes years, of planning went into opening mines and mining camps. This is a photograph of the TCI survey party at Gamble Mines. Tents were not uncommon on mining sites. Before a mine could open, the ground had to be surveyed and timber had to be cut. (Courtesy of Pat Morrison.)

This painting was produced by a miner for Krystal Drummond in honor of her family's legacy. It is a portrait of Heman Drummond and his loyal mule Ole Tobe, seen at the first mine he opened at Sipsey. The painting symbolizes the loyalty of miners and their thankfulness for the opportunity to make a good living for their families. (Courtesy of the Drummond Company.)

First-aid stations are located underground, as per federal law. The stations provide everything a miner might need, from aspirin for headaches, to medicine to soothe upset stomachs. Such first-aid stations are instrumental in life-and-death emergencies. Doctors once went underground to see patients. Today, most first aid is given by first responders. (Courtesy of Horace Defore.)

This couple is taking a ride in front of the Ruby Mines No. 2 commissary. The Ruby Mines was located in Cordova. The mine shipped much of its coal directly on the Warrior River. (Courtesy of Pat Morrison.)

Bathhouses were unique in Walker County. Most houses did not have indoor plumbing, so a good bath was welcome after working a shift in the mine, covered in coal dust. This photograph was taken at the Calimet Mine in Parrish. (Courtesy of the Library of Congress.)

Alabama senator Robert Wilson (center right) poses for a photograph with his family at the opening of Bevill State Community College's Mining Program. He was an avid promoter of Alabama's coal industry. Born in a coal camp in Dora, Wilson was raised in Jasper. The building is named in his honor. (Courtesy of Bevill State Community College.)

This little girl is showing off her house at the Bankhead Mining Camp. She proudly displays her clothes, as well as a doll and photographs on the table. (Courtesy of the Library of Congress.)

This is a photograph of the No. 10 commissary at Horse Creek. The mine was operated by Pratt Consolidated Coal Company. Later, Pratt Fuel Company bought the mine. (Courtesy of Lucille Singleton.)

Rod Roberts poses with a Cupps Coal Company mining car. He worked at the Alabama mining museum before becoming Dora's city clerk. The museum was established in 1982 by the East Walker Chamber of Commerce. Yerby Auxford was the first curator. The museum is housed in the gymnasium of the old Dora High School, which was built by the WPA. (Courtesy of the Drummond Company.)

Sometimes, a mining camp did not have houses ready for workers, especially temporary workers. Timber men would often camp at mining locations in order to clear the land. In this photograph, tents can be seen in the background, set up for workers and their families. (Courtesy of Pat Morrison.)

When miners had a rare break, they let loose. Here, workers pose in front of the dance hall for African American employees at Yerkwood. Each weekend, the hall was packed with miners and their wives. Some men took dates who did not live at the camp to the dance hall. This photograph was taken in the 1920s, so one can imagine tunes like "Sweet Georgia Brown" and "Liza" blaring inside. (Courtesy of Horace Defore.)

Shown here is the railroad at the Drifton Mines. The building on the right, used by workers, would accompany them as they progressed down the railroad tracks. As work was completed, the building was placed on the rails and moved to a new location. All types of workers were constantly arriving and leaving at mines. (Courtesy of Pat Morrison.)

The Bankhead Mine houses must not have had indoor plumbing. This little girl drinks water from a bucket and ladle. Entire families would drink from the same ladle. This was fine, unless a family member was dipping snuff. Note the raw floors and walls. In the winter, families would often put newspapers over holes to insulate the house. (Courtesy of the National Archives.)

Boardinghouses were used by those visiting mine workers and by single men. A miner could stay in a boardinghouse for a daily rate or by the month. An added benefit was that many of these facilities had a house family that served meals—for a price, of course. This is a photograph of the Empire Mines boardinghouse. (Courtesy of Horace Defore.)

This is a shovel from the 1979 ground breaking of the simulated mining building at Walker State Technical College. Although many of the mines from the 1940s had closed, firms such as the Drummond Company were still operating mines in Walker County. The simulated mine building imitates the underground conditions of mines. The program has been visited by mining schools and companies from around the world. The most recent visitors were from Ukraine. (Courtesy of Bevill State.)

This is a 1900 receipt from the Black Creek Coal Company in Nauvoo. Augustus Whitfield served as secretary and treasurer of the company before starting his own firm in Kentucky. (Courtesy of Pat Morrison.)

This is scrip from Oakman Mining Company. While clacker was more like coins, scrip was printed on paper. The Oakman Mining Company's general manager was George Hooper. (Courtesy of collectingalabama.com.)

Although miners were not segregated underground, company housing was. This is a house for African American employees of the Nelson Coal Company at Red Star. Note the pride taken by the family living here, indicated by flowers on the porch. (Courtesy of Horace Defore.)

The coal-miner statue is well known by local miners. He is seen here between Lucille Singleton (left) and Nina Lauderdale. The pair had received an award from Gov. Guy Hunt for their work at the museum in the Alabama Reunion, created by Guy Hunt in 1989 as a way to encourage tourism. (Courtesy of Liz Williams.)

Mining wives had to be tough. When not worrying about their husbands working underground, they had a household to run and children to feed. This woman is most likely doing laundry in the large pot using lye soap. This photograph was taken at the Bankhead Mines. (Courtesy of the Library of Congress.)

Each mining camp had a school with highly educated teachers. The DeBardeleben Sipsey School taught children of all ages. Pupils were grouped together by age and education level in three classrooms on the bottom floor. The upper floor housed the Masonic lodge. (Courtesy of Horace Defore.)

Shown here is housing for white miners at Bankhead. A man is seen comfortably sitting on his porch, likely taking a much-needed break from the mines. (Courtesy of the National Archives.)

This photograph depicts the Lower No. 7 along downtown Dora. The mining camp and mine was located to the right of the train tracks. (Courtesy of Pat Morrison.)

At one time, no politician could be elected in the county without the backing of the UMWA. Shown here is Richard Trumpka (left) and James Singleton at a UMWA rally at the Alabama Mining Museum. At the time, Trumpka was president of the UMWA. Today, he is the president of the AFL-CIO. (Courtesy of Lucille Singleton.)

Shown here is the Yerkwood commissary. Frank Nelson began the Nelson Coal Company, which opened the Yerkwood mining community. Later, he was president of the Burnwell Coal Company, which ran the mine. (Courtesy of Horace Defore.)

This is an interior view of the Yerkwood Commissary. M.L. Tubbs ran the commissary for the Burnwell Coal Company. Miners' wives could purchase whatever they wanted by going to the mine office while their husbands were underground. (Courtesy of Horace Defore.)

This is an aged photograph of the last house at Magellan Bottoms. Long after the remaining houses were torn down in the camp, an elderly African American lady lived there. Shortly after she passed away in her 90s, the house was razed, and the mining camp disappeared. (Courtesy of Lucille Singleton.)

H.W. Quarles ran the commissary at Empire. Mining families could purchase everything from flour to clothing to jewelry. Going to the commissary was a special treat for children. (Courtesy of Horace Defore.)

On the left is the African American church at the Empire camp. In most cases, churches also served as schools at mining camps. At Empire, however, African Americans had a school that was led by a Harvard-educated teacher. (Courtesy of Horace Defore.)

This is a 1937 photograph commemorating the UMWA Birmingham District miners. This was only the fourth meeting of the United Mine Workers of America. Hugh Lee Cunningham is marked with an x. (Courtesy of Margaret Parker.)

John L. Lewis (left) and Sen. Joseph Guffey of Pennsylvania (right) were avid supporters of the Guffey-Snyder Act. The legislation created a commission to regulate mine worker hours and wages. The act was deemed unconstitutional, because it violated the notion of free enterprise. Lewis and Guffey went back to the drawing board, and the Guffey-Vinson Act was passed. They are seen here leaving the White House. (Courtesy of the Library of Congress.)

The SEGCO retirees meet annually for a reunion at the Harbin Hotel in Nauvoo. The retirees seen here in 2001 are in line for a buffet meal. Gene McDaniel, the owner of the hotel and retiree, is in the back middle of the photograph. (Courtesy of Dot Daniel.)

The Burnwell Coal Company's Red Star commissary is seen here between 1922 and 1937. The Red Star Mine was not located on Red Star Hill in Dora, but was actually behind the hill between Red Star and Horse Creek Boulevard. (Courtesy of Horace Defore.)

The simulated mining building at Bevill State was erected for $450,000. It houses several programs. On November 18, 1997, an actual mining simulator was added. (Courtesy of Bevill State Community College.)

Leo Dutton (second from left) and Floyd Fuller (far right) stand outside of the Local No. 1881. The Union Hall, seen in the left corner behind them, was located on Main Drive in Parrish. The union hall has since closed and the building no longer exists. Parrish was once home to many union halls during its heyday. (Courtesy of J.D. Daniel.)

This is a company deputy at the Coal Valley mining camp. This camp was very active in attempts to unionize, so the DeBardelebens hired deputies to patrol the facility. After a disruption at the camp, Governor Kilby dispatched the Alabama National Guard to patrol Walker County. Unionizers responded by blowing up a bridge leading to the mines. (Courtesy of Pat Morrison.)

Housing for miners was segregated by area, but the miners lived in similar structures. This photograph shows housing for white miners at Empire. (Courtesy of Horace Defore.)

The railroad, timber companies, and mines worked together. Without one, the others could not exist. This photograph shows a train hauling timber. (Courtesy of Pat Morrison.)

The Alabama Mining Museum in Dora preserves the history of Alabama's coalfields. Some of the exhibits can be seen in this photograph. The museum is open Tuesday through Saturday, from 10:00 a.m. until 2:00 p.m. (Courtesy of the Library of Congress.)

Outhouses were once a familiar sight, such as this one at the Railway Fuel Mine in Parrish. The mining companies employed people to empty the outhouses. Lime was sprinkled on the ground around the outhouses as a cleaner and disinfectant. (Courtesy of Horace Defore.)

This photograph shows how many people were employed and lived at Wegra. There are two different pronunciations of the name; the most common is "Wigree." Today, the road to the mine is closed. The mine was located between Goodsprings and West Jefferson. (Courtesy of Horace Defore.)

This is an example of a mine office. These men are filling out a fire log after a shift. These logs are very important to miner safety. A mine employs a fire boss, who enters the mine between shifts to detect gases and ensure other safety precautions. Fire logs help to keep miners alive. (Courtesy of Dot Daniel.)

This is a street scene at the Bankhead Mining Camp. Judging by the children on the porch, this street was for white residents. This photograph was taken in 1946. (Courtesy of the National Archives.)

Bathhouses were common for miners, but rare in the greater communities. This is the Sipsey bathhouse. Often, families would sneak in to take a shower when the house was not in use. (Courtesy of the National Archives.)

This is a touching photograph of Etta Petty and her grandfather Lunie Petty, who worked at the SEGCO Mine. This photograph was taken in Parrish at the Stanley camp. Attention should be paid to Etta's hat, as she is now a well-known milliner in New York City. (Courtesy of Etta Petty.)

Shown here is the Sipsey boardinghouse. For a small amount of money, miners could stay at the house. Salesmen and other mining officials would stay at boardinghouses while visiting on official business. (Courtesy of Horace Defore.)

Ivy Paul Andrews was an avid baseball player. He played for mining-camp teams in Dora and Empire. His pitching skills led him to the major leagues. Andrews played for the Yankees, Browns, Red Sox, and Indians. (Courtesy of Susan Defore.)

The children of William McMillan look out of a mining camp house at the Calimet Mines. Note the wash bucket and Delta lye soap on the table. (Courtesy of the National Archives.)

This is the Railway Fuel Company's first aid station in Parrish. Such stations were needed in all of the mines. Doctors were employed by each of the mining companies. Some of them went on to eternal fame, such as Dr. Carraway, who opened the Carraway Hospital. He often went underground to aid miners who had been in a disaster. (Courtesy of Horace Defore.)

This mural was painted by local artist Vance Wesson for the Alabama Mining Museum. The mural depicts scenes of mining life. Wesson, a famous Alabama artist, also painted the mural at the Southtown Housing Project in Birmingham. (Courtesy of Dot Daniel.)

Heman and Elza Drummond lived in Sipsey, where they raised five sons and two daughters. All of the sons worked for the company. Garry Drummond has been the CEO of the Drummond Company since the early 1970s. "Mama" Drummond passed away, but the family still gathers at the house every year for Christmas. (Courtesy of the Drummond Company.)

Shown here is white housing at the Sipsey camp. This must have belonged to a foreman or upper-level employee, as it is a large house. (Courtesy of Horace Defore.)

The Union Church at Sipsey belonged to no particular denomination. Rose Fies, the wife of Henry Fies, was adamant that all churchgoers should be students of the Bible and not emphasize particular denominations. The church is still open today. Rev. Buell Harris is the current pastor. (Courtesy of Horace Defore.)

Seen here is an aerial photograph of the mining camp at Sipsey in the 1960s. Located on the right are the Sipsey School and Sipsey City Hall. (Courtesy of Horace Defore.)

This is Frisco railroad steam engine was housed on the grounds of Walker College before being donated to the Alabama Mining Museum, where it is located today. (Courtesy of Lucille Singleton.)

This photograph shows white housing at Yerkwood. Most of the housing was built alike at that time, despite being in different camps and owned by different companies. Most of the houses had four rooms. (Courtesy of Horace Defore.)

115

This is a mining house at Red Star. All of the camp houses were built alike, with four rooms. Nelson Coal originally opened this mining community. The owner of the company also created the Bryan Coal Company, which operated mines around Bryan Road. (Courtesy of Horace Defore.)

Don Blaylock poses for a photograph at a reunion for the UMWA District 20 sub-district 28. Miners develop a close-knit brotherhood that lasts long after they retire. The miners use every opportunity to gather and reminisce about the past. (Courtesy of the SEGCO retirees.)

Coal tipples were a favorite playground of children in mining camps, although mine companies strongly discouraged the practice. It was very dangerous to play on tipples. (Courtesy of the Library of Congress.)

This photograph shows a fossil found at Crescent Valley Mine in Carbon Hill. The first fossils were found at the Galloway No. 11 mines. Miners discovered the fossil tracks in the 1920s. Fossils have also been found at Union Chapel. Dr. Ron Gupta has chronicled his historical finds in the book *Footprints in Stone: Fossil Traces of Coal-Age Tetrapods*. (Courtesy of Dr. Ron Gupta.)

When the simulated mine building was dedicated at Bevill State, it was big news in Alabama. It was the first mining program in the state. Gov. George Wallace (in wheelchair) spoke at the event. He was instrumental in the establishment of trade schools in Alabama. (Courtesy of Bevill State Community College.)

Shown here is the back of a camp house. This is another house from the Bankhead mining camp. The girls are children of Carlos Wilson, who works in the mines. (Courtesy of National Archives.)

This memorial at the Alabama Mining Museum honors the 13 miners who were killed at the Jim Walter Resource No. 5 mine in 2001. One of the miners, Terry Stewart, was from Cordova. He was killed after he ran to help the miners who were hurt. (Courtesy of the Alabama Mining Museum.)

This photograph shows white housing for the employees of Railway Fuel Company in Parrish. Railway Fuel Company was the scene of one of the worst mine disasters in the county's history. In 1920, an explosion killed 12 men and injured eight others. Many of the men lived in company housing like that pictured here. (Courtesy of Horace Defore.)

The "white church" in Dora received its name because it was the first painted church in the area. Like most churches in mining communities, it was Baptist and Methodist at different times. Today, it is known as Dora Second Baptist Church. Between the church and West Pratt was Calico Hill. It was here that the very first painted houses were built by a mining company in Dora. (Courtesy of Lucille Singleton.)

People still lived in the camp houses at Flat Creek in the 1980s, when this photograph was taken. Although the mine had long closed, Alabama By-Products still rented out the houses for a low price to people who had lived in the camp for years. If a renter needed a handyman, G.W. Campbell of Dora was employed. Only a few of the homes are still in existence today. (Courtesy of Horace Defore.)

The Sipsey mining camp at one time housed over 900 employees. This photograph of the theater was taken in 1918, at the height of the coal boom. The formation of unions allowed the miners to have more free time, although time to relax was still very scarce. The theater gave them an opportunity to unwind. The Sipsey theater showed a movie on Saturdays and two on Sundays. It was a welcomed break for miners and their families. (Courtesy of Horace Defore.)

The Sipsey commissary, pictured here in 1923, was both a store and a gathering place. The Sipsey coal camp was truly a town. Shortly after the mining camp was formed by Marylan Coal Company, the town of Sipsey was founded in 1912. Henry DeBardelben, who founded the camp, was a son-in-law of the famous Pratt family. He hired an architect to design his dream mining town. He later changed the name of the company to DeBardelben Coal & Iron Company when it merged with the Corona Coal Company. The firm became one of the most prominent mining companies in the South. (Courtesy of Horace Defore.)

The new railroad brought growth to Parrish. With an output of 3,000 tons of coal a day, the Railway Fuel Company decided to build additional homes to house miners. The camp became so crowded that a new school had to be built. This photograph shows the progress of the new school. (Courtesy of Horace Defore.)

This train hauled coal at Sipsey. Seen here in 1928, it was owned by the DeBardeleben Coal Company. (Courtesy of the Ralph Hawkins collection.)

Three
WALKER COUNTY TODAY

The Shoal Creek Mine, operated by the Drummond Company, is the largest mine in operation in Alabama. It extends from Jefferson into Walker County. The mine produces almost two million tons of coal a year and employs many miners who live in Walker County. It is unique, because the mine runs underneath the Warrior River and is 1,300 feet deep. (Courtesy of the Drummond Company.)

Shown here is the reclaimed land at Jim Walter Resources' Choctaw Mine in Goodsprings. The surface mine is on the ground where the SEGCO mine was once located. (Author's collection.)

The Barney Miner Memorial was erected in 1989 by the Barney Cemetery Board to honor the memory of all local miners. Some of the miners worked at the Barney Mines, others were buried at the cemetery. (Author's collection.)

Adrian Northcutt, a minister, was in his home in 1920 when the Alabama Guard knocked on his door, demanding that he come outside. He obliged, and the guards shot him seven times. His son-in-law, Willie Baird, ran out of the house to find him dead. After a scuffle with the guardsmen, Baird shot and killed Pvt. John Morris in self-defense. Baird ran, but later turned himself in to the Walker County authorities, convinced that a jury of his peers would rule his deed self-defense. Before the case could go to trial, Alabama Company M stormed the jail and hung and shot Baird. (Author's collection.)

The Carbon Hill miner memorial was built to honor the miners on whose backs the city was built. Carbon Hill was once so full of miners that recruits tried to hire family men, with the idea that women would calm the town. The idea worked, although a row or two still took place. Bricks have been purchased in honor of miners, and these will soon be added to the monument. (Author's collection.)

The UMWA Local 6855 built the Lewis Memorial to honor John L. Lewis, the famous UMWA president. Lewis spent his life fighting for the rights of workers. (Author's collection.)

This is the Miner Memorial outside of the local union at Nauvoo. The memorial commemorates all of the miners who died in mine accidents. It is the pride of the local at Nauvoo. Local Union No. 6855 can be seen in the background. The union hall is now closed, but it reminds visitors of a bygone era. (Author's collection.)

126

Shown here is UMWA Local No. 1948. The union hall is located in Goodsprings, off Highway 269. The union hall is still active and holds monthly meetings. (Author's collection.)

DISCOVER THOUSANDS OF LOCAL HISTORY BOOKS FEATURING MILLIONS OF VINTAGE IMAGES

Arcadia Publishing, the leading local history publisher in the United States, is committed to making history accessible and meaningful through publishing books that celebrate and preserve the heritage of America's people and places.

Find more books like this at
www.arcadiapublishing.com

Search for your hometown history, your old stomping grounds, and even your favorite sports team.

Consistent with our mission to preserve history on a local level, this book was printed in South Carolina on American-made paper and manufactured entirely in the United States. Products carrying the accredited Forest Stewardship Council (FSC) label are printed on 100 percent FSC-certified paper.

MADE IN THE USA